W9-DHK-546

Eastern Ceramics

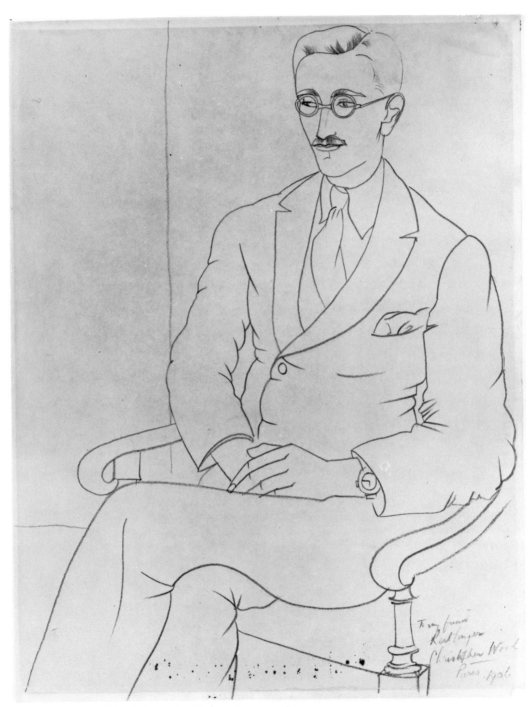

A portrait of Gerald Reitlinger by Christopher Wood.

Eastern Ceramics
and other works of art
from the collection of
Gerald Reitlinger

Catalogue of the Memorial Exhibition

Ashmolean Museum
Sotheby Parke Bernet

217986

First published 1981 for the Ashmolean Museum and
Sotheby Parke Bernet Publications by
Philip Wilson Publishers Ltd,
Russell Chambers, Covent Garden, London WC2E 8AA

Edition for the USA available from
Sotheby Parke Bernet Publications,
c/o Biblio Distribution Centre,
81 Adams Drive, Totowa, New Jersey 07512

ISBN : 0 85667 115 0 hardback
ISBN : 0 90009 078 2 paperback

Filmset and printed in England by
BAS Printers Limited, Over Wallop, Hampshire
and bound by Weatherby Woolnough, Wellingborough.

Contents

Foreword

This volume catalogues a selection—a very considerable selection, but by no means the whole—of the greatest benefaction made to the Ashmolean Museum for many years: that of Gerald Reitlinger. The selection is to be shown in the summer of 1981, in a series of exhibitions, in part in Oxford at the Museum, and in part in London.

Gerald Reitlinger's range was fantastic, from Japan across the world westwards to Britain, and aspects of most of this range are represented here. The collection was made over to Oxford by him in his lifetime—in a characteristic manner, vividly recorded by Lord Bullock in his essay, below—and after his death, so tragically hastened by the fire at his house, it was found that he had indeed fulfilled in his will his promise to bequeath resources to enable the Museum to proceed to the proper permanent display and study-storage of his collections. Plans for this are in hand.

We are grateful to Lord Bullock, who was Vice-Chancellor of the University of Oxford when Reitlinger drew up his Deed of Gift, and to Mr Richard de la Mare, old friend and fellow collector, for their illuminating essays, and indebted to Sotheby's both for providing space for the London exhibition in their rooms in Bond Street, and undertaking the publication of this catalogue, which will be a lasting tribute to the memory of Gerald Reitlinger.

David Piper, C.B.E.
Director, Ashmolean Museum
Oxford, 1981

Gerald Reitlinger: a portrait

by the Rt Hon. Lord Bullock, D LITT. F.B.A.

Oxford's libraries and museums have been enriched by many splendid gifts, beginning with Duke Humphrey's Library and continuing with Archbishop Laud's Oriental manuscripts, but in modern times few, if any, can compare with Gerald Reitlinger's magnificent bequest to the Ashmolean.

I had the good fortune to be Vice-Chancellor in the summer of 1972, when Gerald Reitlinger asked to see me. I wondered why. Although I had never met him, his name was familiar from the three books he had written on the Nazis, one of which, *The Final Solution* (1968), first established an authoritative record of Hitler's monstrous attempt to wipe out the European Jews. This came at once to mind, and almost immediately afterwards the three volumes on *The Economics of Taste* (1961-70), a study in the rise and fall of the prices of works of art from 1760 to the 1960s, based upon research which gave him an unrivalled reputation in the field. Perhaps, I thought, he wanted to talk about founding an historical prize or scholarship. I had some inkling of his intentions, however, from the Department of Eastern Art at the Ashmolean Museum, where he had friends who had warned me of a possible benefaction.

When I brought him into the Vice-Chancellor's room at the Clarendon Building, he wasted no time in coming to the point. He had a collection to leave and a proposal to make, a proposal which, he soon made clear, he had put to another museum and been dissatisfied with their response. He left no doubt that the way in which Oxford responded to his offer would decide whether this time he went through with the proposal. His manner was dry, not to say testy; enthusiasm, it was clear, was not the response in which he was interested, still less any fulsome expression of gratitude.

My initial response was to point out—with very good reason at that time—the difficulties the Ashmolean faced in finding space or money to provide accommodation for new acquisitions. This was received coldly, but had evidently been foreseen. He produced a ground plan of the museum, on which he indicated where room could be found, and went on to say that, in addition to the collection, he would make over to the University his house in Sussex, with a large part of the contents and the estate, which could be sold to provide the necessary funds.

I had assumed that Mr Reitlinger was speaking of a bequest by will which would come into effect after his death, as he was already in his seventies. Not at all: he

9

wanted the legal transfer of his collection to the University to take place as soon as possible, but on condition that he should retain it, physically, at Beckley, and continue to live with it for the rest of his life.

I have negotiated with a number of benefactors in my time, but none ever impressed me as did Gerald Reitlinger. By the end of our talk I was not only excited by the prospect of what might come to the University, but put on my mettle to show that Oxford was capable of the flexibility needed to meet his conditions.

In the negotiations that followed two further things became clear. The first was the extraordinary scope and quality of the benefaction the University was being offered. The second was the unusual combination of qualities and range of experience represented in the personality of the benefactor.

Gerald Reitlinger was born in London in 1900, the third son of Albert Reitlinger, a prominent banker, and was educated at Westminster. He was a man who frowned upon the open expression of feelings and was unpredictable in the alternation of charm and irritability. At times he would speak with something like affection for Oxford, which he had first known as an undergraduate at Christ Church immediately after the First World War; at other times he would express total scepticism about the value of universities or any form of education. After leaving Oxford he went on to the Slade, where he studied under Tonks, and the Westminster School of Art, later exhibiting a number of his paintings at the New English Art Club and elsewhere. When asked why he had stopped painting, he replied characteristically: 'Because I wasn't good enough.' But his interest in art remained, and the foundations of his expert knowledge of Oriental art were laid in journeys to the Middle and Far East in the 1930s. In the years 1930-32 he took part in two Oxford University expeditions to Iraq, the first to Kish and the second, which he directed jointly with David Talbot Rice, to Hira. He went on to give accounts of his journeys through Persia and Turkish Armenia in *A Tower of Skulls* (1932), and of a visit to the remote Chinese province of Yunnan in *South of the Clouds* (1939). When at home, he used to invite regular house parties to Thornsdale, near Iden in Kent, and later to Woodgate House at Beckley, a larger house which earned him the title of 'The Squire'. There are vivid glimpses of him in that rôle in the memoirs of the novelist Anthony Powell.

After the war, he began to write frequently for periodicals and newspapers on art and antiques. In the 1950s he produced the books dealing with the Nazi period, of which *The Final Solution* has continued to hold a place in the historical literature. He finally found his real métier in writing his three volumes on *The Economics of Taste*, which enabled him to combine encyclopaedic knowledge and the judgement which he had developed as a connoisseur, with his inherited grasp of finance and his varied, if sceptical, experience of human nature.

More than anything else, however, it was into his collecting he poured the skill and passion of a complicated personality, and it is entirely fitting that it should be the collection he created which will remain as Gerald Reitlinger's permanent memorial. It was built up not by lavish expenditure or the employment of hired

experts, but by the accumulation over many years of a highly individual mixture of taste, flair, knowledge and persistence. When he made the first condition of his gift to the University that it must remain with him intact for his lifetime, he was expressing his deepest feelings.

The long drawn out negotiations had finally been concluded to Mr Reitlinger's satisfaction, but in the event the collection very nearly perished with him. In February 1978, a fire broke out in his house at Beckley, destroyed a portion of it and gutted part of the remainder. Too dazed to be able to help save his collection, Reitlinger was reported to have been found wandering about the grounds broken-hearted at the prospect of a lifetime's work destroyed in a few minutes.

Fortunately he was wrong: it had not been destroyed. Thanks to the well-nigh heroic efforts and care of the East Sussex Fire Brigade, the greater part of it was saved and the part that was lost was the least valuable of the collection. Members of the Ashmolean staff travelled down to camp out alongside it, until it could be taken back to Oxford and the long job of accessioning, cleaning and, in some cases, restoring over two thousand pieces, put in hand.

Gerald Reitlinger never recovered from the shock, and three weeks after the fire died at the age of seventy-eight, but not before he had learned that his collection was safe.

Now, at last, the work of conservation is almost complete and, nine years after our initial meeting in the Clarendon Building, its full glory can be seen. Oxford and the worlds of art and scholarship are permanently enriched by Gerald Reitlinger's magnificent benefaction; and he himself has a memorial in the rôle that gave him the deepest satisfaction—that of a great collector.

Gerald Reitlinger: collector

Richard de la Mare in conversation with Oliver Impey

Woodgate House presented a Regency stucco front on to lawns and rhododen-drons, a smart frontage tacked on to a Sussex farmhouse. Outwardly it seemed the quintessential small country house, though perhaps not in as good a state of repair as some others; if one looked closely one could see where the coade-stone cornice had been replaced by a similar moulding, after it had landed, one day, in a neat line on the front drive.

Inside it was a different world. Gerald Reitlinger was a collector, and a collector who believed in displaying everything. Doubtless, at first, he had merely used shelves and bookcases, but as his collection of Islamic pottery grew, he built, in the middle of the house, the room he always called 'the Museum' with floor-to-ceiling cases and drawers on most of the available wall space. When these cases were full, the collection overflowed on to all the other spaces available. Plates were hung on his home-made wire hangers, suspended from nails banged into the plaster. Where the wall showed off such plates badly, Gerald stuck brown wrapping-paper or scarlet satin behind them. On the chimney piece, in the fireplace, on the covered-over Russian billiard table in the centre of the Museum, along the window sill in serried ranks, there were vases, bottles and bowls.

The broken state of most Islamic ceramics led him to the repair work which became such an important part of his collection. He cared very much for his pieces, mending them and displaying them to his own taste with complete independence. His favourite techniques for the repair of Islamic wares involved plaster and 'Seccotine'. He used gold paint liberally on several of his repairs, in the general style of Japanese lacquer mending.

As the collection expanded to include Chinese and Japanese porcelain, apparently after the Second World War, his whole house became a display area: polychrome-decorated Chinese porcelain in the drawing room and in Gerald's own bedroom, cladding the walls, on every shelf, in cabinets and on the side board. The dining room was elegant and rich with Japanese polychrome, and the two spare bedrooms resplendent with hundreds of blue and white wares from China, Japan and Korea. Latterly, his interest in the European–Asian connection, both in the shape and decoration of ceramics, filled the last available bedroom with tin-glazed earthenware, and the corridor outside the bathroom with German stoneware. The bathroom itself was largely hung with Iznik tiles. The stair-well became the

showplace for Swatow plates, out of reach and difficult to see, but known individually by their owner with precision.

Gerald Reitlinger was a methodical man—he could not have written *The Economics of Taste* if he had not been—and he recorded on cards every piece in his collection. On each card he would describe the piece and give details of where he had bought, or with whom exchanged it, how much it had cost, and so on. In later years he added sale-room prices for similar pieces, so that for some pieces one has a comparative chart of escalating prices.

Richard de la Mare, one of the first co-directors of the publishing house Faber & Faber, who established the 'Monograph' series on pottery and porcelain, was a fellow collector and friend of Gerald Reitlinger's. He remembers first meeting him some time before the war:

He was brought to see me by Robert Jessel, with whom he had become friends when they were studying painting together in Paris. We hit it off very well, and after that he came more than once. In 1939, we published a book of his called *South of the Clouds: from Saigon and Yunnan into Burma*. Later on I wanted him to write on Transitional Ming for the Faber 'Monographs'; we did discuss it, but he was never prepared to give the time to it, and it got no further.

The first time I visited Gerald at Woodgate House must have been early in the war. Shortly after that, the house was requisitioned rather suddenly and he had to pack up all his Islamic pottery in boxes and store it away in his cellar, and of course the cellar wasn't dry enough and the whole lot fell to pieces again.

In those days the hunting ground for collectors was the junk auction room, Fosters of Pall Mall. After the war, the main source of Chinese ceramics was Monks in Church Street, Kensington. Monks in its heyday had masses of Transitional blue and white. You could have bought twenty or thirty pieces any time you went in, for about three or four pounds a piece. I expect Gerald bought much of his Transitional blue and white there. Of course, he did do a lot of exchanging of pieces with other collectors. Soame [Jenyns] used to complain that Gerald always came off best. I only remember ever exchanging one piece with him—a little Transitional Ming cylindrical vase which I swapped for one of Gerald's Korean bottles. I have it still, and I think in this case I came off the better. There is nothing to equal the quality of Transitional Ming blue and white at its best, with a beautiful glaze and very good drawing; I think it has all the merits. And it has been rather neglected so far. The Chinese taste pieces that Gerald collected are also of this quality; I think he was one of the first people over here really to appreciate Chinese taste enamelled porcelain. Until then nobody was paying much attention—they were still busy buying ruby-back plates.

I think Gerald started his collection of Japanese porcelain because he had seen mine. The collectors scorned it and no dealer would touch it, so for years I had the field almost to myself. Of course Billy Winkworth collected it, and after the war Soame Jenyns started, and then Gerald. We all used to buy at a shop run by Wilfred Lickorish, who used to buy the Japanese pieces that the other dealers had bought with other things. Even at Sotheby's things were comparatively cheap. Gerald, of course, never cared if objects were broken or cracked; he never bought anything with the idea of selling it. He never spent much money on anything—his attitude always was that he couldn't afford it—but he did buy a lot. When my wife and I went to stay with him one weekend, I

remember lying in bed in the spare bedroom counting the blue and white pieces: two hundred and sixty pieces of blue and white porcelain!

Now that the collections of most of Gerald's contemporaries have been dispersed, it is good to know that his collection will be preserved in its entirety.

Plate I

Plate II

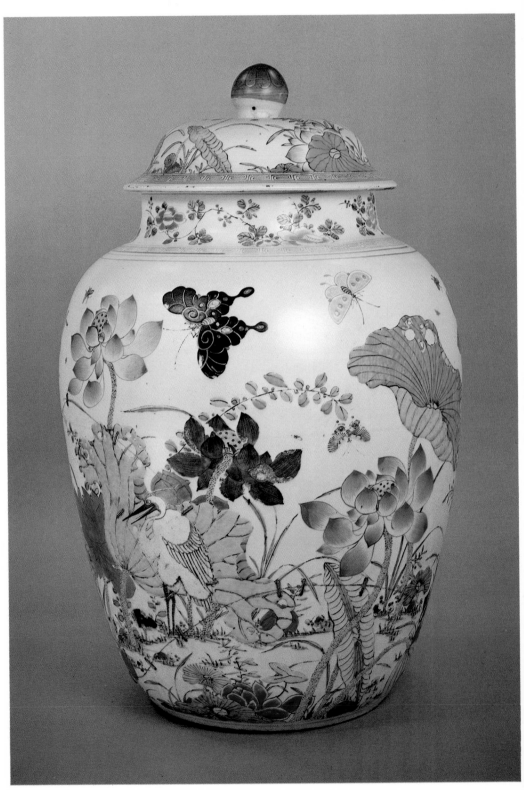

No. 117

Plate VII

Plate VIII

The Catalogue

Note

Accession numbers are given at the end of each entry.

Measurements have been abbreviated in the captions as follows: Height, H; Diameter, D; Foot Diameter, Ft.D; Width, W; Foot Width, Ft.W; Length, L.
The diameter is given at the widest point, except where the foot diameter is greater, in which cases the diameter is given at the rim. Height and diameter measurements include mounts for the appropriate pieces.

Acknowledgements

Catalogue edited by Deborah Willis

The Ashmolean Museum would like to express special thanks to the following people for their help in accessioning, restoring and cataloguing the Reitlinger Collection: Jane Christie-Miller, Geraldine Beasley, Rachel Outhwaite, Dinah Reynolds, Ann Tapper, Jill Wellesley, and the five members of the Job Creation Group who worked on the initial registration of the collection.

Chinese ceramics

Gerald Reitlinger collected Chinese porcelain over several decades, from the 1930s to the 1970s, and he seems to have started with the later periods of the eighteenth and nineteenth centuries and moved backwards in time, although never further than the late fourteenth century. Always these were decorated pieces, for the subject and style of decoration were his chief interest. The selection of pieces from the collection for exhibition has therefore been made to stress this aspect. In particular, there is a stress on the style and period with which he was especially associated, that of the so-called 'Transitional wares' of Jingdezhen. Notable amongst this group is the style of painting in underglaze blue which he called the style of the 'Master of the Rocks', defining the most painterly quality of decoration in an already refined style.

The taste for decoration which binds the collection together shows a predilection for figures and illustrative decoration and picks up the threads of Chinese blue and white decoration in the sixteenth century. At this time, the growing popularity of figurative scenes forming the main zone of decoration meant that a whole school of ceramic decoration grew up, centred on the slightly less formal wares of Jingdezhen. Within this huge complex of kilns there was room for a very varied production at any one time; a spectrum of wares ranging from grand and formal palace pieces, through many less formal wares, to the *min yao* or 'people's ware', of which export wares were eventually a variant. The rich blue decoration of the sixteenth-century wares is a delightful combination of flower scroll, bird and dragon motifs with a freely painted scene, which is often Taoist or Buddhist and of obscure iconography. The identity of monks and Immortals in landscape may be uncertain, but the whole pantheon of Buddhist and Taoist personalities is here, sometimes even together. The element of 'good wishes' and presentation symbolism is also evident. Thus Shou Lao, the Taoist Immortal associated with longevity, is often seen with the group of *Ba Xian*, the Eight Immortals, otherwise their attributes may stand for them in borders, or on the outside decoration of dishes. 'Good wishes' marks are popular and symbols such as bats and peaches abound. The shapes of upright vessels of this period are in the tradition of earlier Ming wares, often owing something to Middle Eastern and traditional Chinese metal vessels. The more bizarre forms of *kendi* reflect both the taste for the exotic, evident in most periods in China, and also the growing importance to Jingdezhen of the export trade.

19

This trade became a major element in the output of the newly revivified kilns which moved into full production by the Kangxi reign (1662-1722). As with so many other decorative crafts, the last half of the seventeenth century was a period of innovation and rapidly increasing output of porcelain at Jingdezhen. The style of decoration had changed from the Ming 'good wishes' style of figures in landscapes to reproductions of printed and painted illustrations from the many illustrated books being produced at the time. In the difficult period of the change of dynasty, a change in taste seems to have come into play which governed the quite evident change of style at Jingdezhen. This again is shown most clearly in the non-Imperial style wares. The style of underglaze blue painting on a fine white body is that of a book illustration wrapped around the vessel, which inevitably then has a 'right' side, the edges of the picture melting away in clouds or concealed behind a banana palm. The most popular subjects were the newly produced illustrations for such old favourites as *Xixiang Ji* and *Xui Hu Zhuan*, romantic drama and adventure stories of historical heroes. Buddhist and Taoist subjects continued but were more explicit and often included a text. Not only is the subject matter quite new but also many of the shapes of these wares seem to be unique to the period. The smoothed-out curve of the trumpet vase (No. 64) and brush jar (No. 66), is a variant of the ancient bronze *gu* shape, and the rounded vase (eg Nos 58–61) in many versions seems to be an innovation associated only with this period and style of decoration. For the quite distinctive style of painting in cobalt on the finest pieces (Nos 84–92), Mr Reitlinger coined the useful term, 'Master of the Rocks'. The export wares of the same period quite naturally show more evidence of interest in European shapes and motifs but are adjudged to be of the same date and also from Jingdezhen. The early eighteenth-century style of blue and white is a crystallisation of the earlier style, whilst in polychrome the strength of design and clarity of colour produced some of the finest work in this technique. The mid to late seventeenth-century examples (eg Nos 39, 40) show a transition between Ming and Qing motifs even more clearly than the blue and white. By the eighteenth century, the full Kangxi style is brought to polychrome decoration, and the Jingdezhen style was established. The present collection displays again the development of this style with the addition of pink (colloidal gold), white (arsenic), and yellow (cadmium) to the palette, represented by the good quality non-imperial style (Nos 132–135, 141) and, most interestingly, in the *min yao* style (No. 140). Once again export wares are a variant of this latter style and the eighteenth–nineteenth-century versions are well known in this country.

M. Tregear

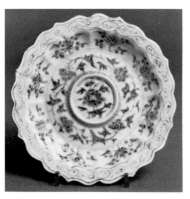

1 Cup stand

Cup stand saucer with flattened foliate rim, lobed cavetto and raised central ring. Decorated in a slightly misfired, grey, underglaze blue, with lotus and peony sprays, and bands of scroll and lappet ornament. Outside plain. Low, neat foot ring and unglazed base.
H: 2.6cm D: 19.5cm Ft.D: 12cm
Late 14th century
1978.901

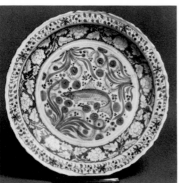

2 Dish

Large deep dish with flattened foliate rim turned up slightly at the edge. Decorated in underglaze blue with a carp swimming among waterweeds; the cavetto wall decorated with a floral wreath, white on blue. Outside, a lotus wreath. Shallow sloping foot ring and unglazed base.
H: 8cm D: 46.5cm Ft. D: 25cm
Late 14th century
1978.911

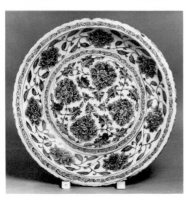

3 Dish

Large deep dish with flattened, slightly foliate rim. Decorated in underglaze blue with four peony sprays in the centre, and seven on the cavetto, with narrow bands of classic scroll. Outside, seven peony sprays bordered by classic scroll. Low sloping foot ring and deeply recessed unglazed base.
H: 9cm D: 51cm Ft.D: 29cm
Late 15th century
1978.2105

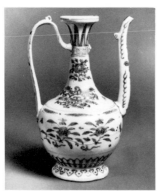

4 Ewer

Tall-necked ewer with long curving handle and spout, a small loop at top of handle to take a mount for a cover. Decorated in underglaze blue in encircling bands from neck to base, with various types of scroll and lappets, the main zone with peony sprays, butterflies and dragonflies. Deeply recessed base, glazed, with a six-character mark of Xuande in a double circle.
H: 23.6cm D: 13.1cm Ft.D: 8.8cm
c. 1500
1978.887

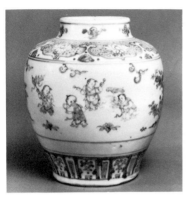

5 Jar

High-shouldered jar, decorated in underglaze blue with children playing in a garden with fences and flowers. Subsidiary encircling bands of fungus sprays, lappets and lotus panels. Low cut-out foot ring and unglazed base.
H: 21cm D: 19.7cm Ft.D: 12cm
c. 1500
1978.2052

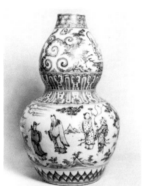

6 Double-gourd vase

Large double-gourd vase with straight rim. Decorated in underglaze blue: on the upper bulb, Shou Lao, and on the lower, the Eight Immortals in a landscape. Encircling bands of floral diaper, lotus panels and lotus petals. Slightly concave unglazed base.
H: 49.8cm D: 31.2 cm Ft.D: 18.2 cm
Early 16th century
1978.875

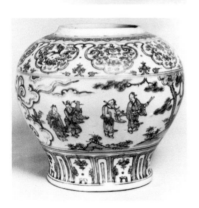

7 Jar

Large jar with bulbous body, the short neck left unglazed to take a cover. Decorated in underglaze blue with Shou Lao and the Eight Immortals in a landscape. Encircling bands of *ruyi* lappets and lotus panels. Narrow spreading foot and flat unglazed base.
H: 28.2cm D: 32.4cm Ft.D: 20.8cm
Early 16th century
1978.920

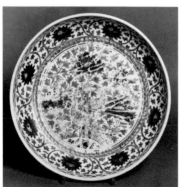

8 Dish

Large saucer dish decorated in overglaze red, green and (iron) yellow enamels. In the centre, two peacocks among peony plants; on the sides, both inside and out, a lotus scroll, with subsidiary bands of wave pattern, lappets, diaper pattern and flags. Low sloping foot ring and unglazed base with a mark, 正, in iron red.
H: 6.7cm D: 34.2cm Ft.D: 22.7cm
c. 1500
1978.1076

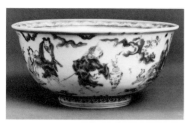

9 Bowl

Bowl with slightly everted rim, decorated in overglaze red, green, yellow and brown enamels: inside, a medallion containing traces of a creature offering a basket of fruit to a figure; outside, a continuous landscape with Shou Lao and the Eight Immortals. Bands of wave and simplified scroll pattern. Tall foot ring, base glazed with a rough mark, 上.
H: 9.2cm D: 20.9 cm Ft.D: 9.2 cm
c. 1500
1978.1875

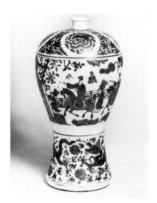

10 Vase

Vase of exaggerated *meiping* shape. Decorated in underglaze blue: in the main zone, two scholars on horseback with four attendants approaching a pavilion; on the shoulder, a lappet collar and phoenix medallions with cloud scrolls; on foot, dragons among peony scrolls. Unglazed base with a vestigial foot ring.
H: 29.3cm D: 16cm Ft.D: 11.7cm
Early 16th century
1978.2000

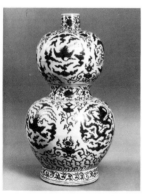

11 Double-gourd vase

Large double-gourd vase with short cylindrical neck. Decorated in underglaze blue with phoenixes, cranes and cloud scrolls arranged in medallions, with bands of floral scroll, lotus panels and curved trefoil lappets. Recessed base, glazed, with a six-character mark of Jiajing.
H: 48cm D: 25.7cm Ft.D: 17.5cm
Early 16th century
1978.938

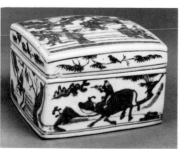

12 Box with cover

Square box with externally fitting cover. Decorated in underglaze blue: on the cover, a scene of figures on a terrace; a bird on a bough on each side. On each side of the box, a scholar in a landscape, two with oxen. Slightly recessed base, glazed, with a four-character good luck mark, *wan fu yu tong*, in a double square.
H: 9cm L: 13.3cm
Late 16th century
1978.864

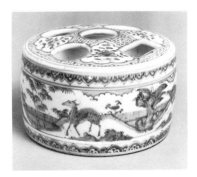

13 Brush washer

Cylindrical brush washer with one rectangular and four round holes pierced in the top. Decorated in underglaze blue with deer and cranes in a landscape, between encircling lappet bands. On the top, four flower sprays in lobed panels against a diaper ground. Inside glazed. Recessed base, glazed, with a four-character mark of Xuande in a double circle.
H: 7.7cm D: 13.3cm
First quarter 17th century
1978.855

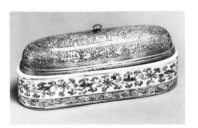

14 Box with brass cover

Long elliptical writing box with moulded interior fittings. Decorated in underglaze blue with fungus and classic scroll bands; diaper ornament inside. The base almost flat, with a wide, very shallow foot rim and traces of glaze. The original flat cover is replaced by a nineteenth-century one of Persian brass.
H: 10.5cm L: 24.6cm
Early 16th century
1978.859

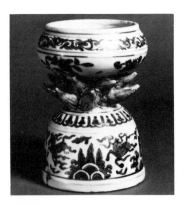

15 Cup stand

Hollow cup stand in two sections, with an intermediate ring of moulded limpet shapes. Decorated in underglaze blue with floral and fungus sprays on the cup, horses leaping among waves on the foot, and encircling bands of foliage scroll and lotus panels. The inside plain, glazed.
H: 13.8cm D: 10cm Ft.D: 9.4cm
Early 16th century
1978.832

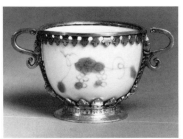

16 Cup with silver-gilt mounts

Miniature cup decorated in underglaze blue with two sprays of vine gourd, the inside plain. Small foot, base glazed, no mark. Two-handled silver-gilt mounts: European, early seventeenth century.
H: 4.2cm D: 5.2cm Ft.D: 3.5cm
Late 16th–early 17th century
1978.817

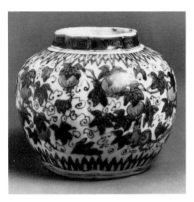

17 Jar

Wide-necked jar moulded in eight lobes. Decorated in underglaze blue with an over-all design of tendrilled vine gourds, two tree shrews gnawing at the fruit; encircling bands of key-fret and flag ornament. Recessed glazed base, no mark.
H: 13cm D: 15.9cm Ft.D: 10cm
Early 17th century
1978.952

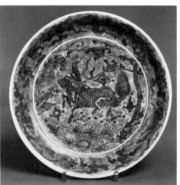

18 Dish

Saucer dish with everted rim. Decorated in underglaze blue against a background of overglaze red enamel, with a prancing kylin among Taoist attributes in a landscape, and a border of kylin, horse, tiger and elephant; outside, a band of fungus scroll. Low foot ring; base glazed, with a six-character mark of Wanli in a double circle.
H: 4.3cm D: 25cm Ft.D: 16.1cm
Early 17th century
1978.980

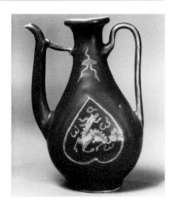

19 Ewer

Ewer with tall handle and spout, the body of flattened pear shape. Decorated in a deep blue glaze over-all, and on either side, in incised slip (oxidised red), a heart-shaped medallion with a prancing kylin among clouds. Roughly formed foot ring, bluish-grey glazed base; no mark.
H: 20.5cm D: 12.2cm Ft.D: 6.2cm
Late 16th century
1978.988

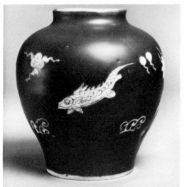

20 Jar

High-shouldered jar, decorated in a deep blue glaze over-all, with fishes and scroll motifs representing waves and waterweed in incised slip (oxidised red). Very shallow cut-out foot ring; unglazed base.
H: 16.5cm D: 16cm Ft.D: 9.2cm
Late 16th century
1978.1358

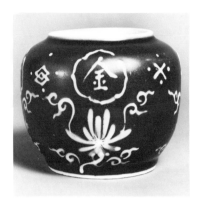

21 Jar

Jar of flattened globular shape, with rim unglazed to take a cover. Decorated in a deep blue glaze over-all, with designs in white slip: on the shoulder, four quatrefoil panels with the characters, *jin yu man tang*; stylised lotus sprays around the foot. Low sloping foot, bluish-grey glazed base; no mark.

H: 11.8cm D: 14.4cm Ft.D: 9.5cm
Late 16th–early 17th century
1978.1126

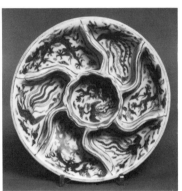

22 Compartmented dish

Dish with six curved divisions around a central well; rim unglazed to take a cover. Decorated in underglaze blue and overglaze red, green, yellow and black, (*wucai*) enamels, with dragons and phoenixes inside and outside, fungus scrolls and key-fret pattern. Low foot ring; base glazed, with a six-character mark of Wanli in a double circle.

H: 5.4cm D: 21.3cm Ft.D: 15cm
Late 16th–early 17th century
1978.1135

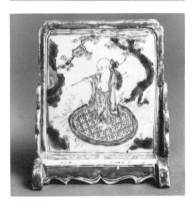

23 Brush-holder screen

Desk screen with two tubular brush holders on one side. Decorated in overglaze red, green and brown enamels, with a pine tree on the brush-holder side, and on the other side, a Lohan beneath a tree; borders of red. Recessed glazed base, no mark.

H. 14.4cm W: 12.9cm
Late 16th century
1978.1229

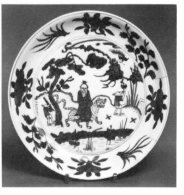

24 Dish

Saucer dish with everted rim. Decorated in underglaze blue with a Buddhist Immortal riding a tiger, attended by two animals carrying symbolic objects, a centipede in the sky above; border of flower and foliage sprays; outside, foliage sprays alternate with snake, toad, centipede, scorpion and lizard, a simple scroll band at the foot. Low foot ring; base glazed, with a six-character mark of Wanli in a double circle.

H: 5.2cm D: 26.8cm Ft.D: 17.6cm
Late 16th–early 17th century
1978.1911

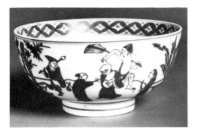

25 Bowl

Bowl with rounded sides, decorated in underglaze blue:
inside, a central medallion with two birds in a flowering
tree; outside, monks and boys playing and laughing,
divided into three groups by plants growing in pots; a
band of diaper pattern at the rim. Small foot ring; base
glazed, with a six-character mark of Wanli in a double
circle.
H: 7.7cm D: 16cm Ft.D: 7cm
Late 16th century
1978.1931

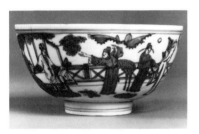

26 Bowl

Bowl with rounded sides, decorated in underglaze blue:
inside, a central medallion with a scholar seated beneath a
pine tree in the moonlight; outside, a theatrical scene on a
terrace under the moon. Small foot ring; base glazed, with
a mark, *fu shou kang ning*, in a double circle.
H: 7.8cm D: 14.9cm Ft.D: 6cm
Late 16th–early 17th century
1978.2015

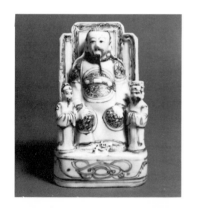

27 Shrine

Figure of Luxing seated on a throne, with two officials
and a tortoise with a snake on its back (the Black Warrior,
symbol of the North). Decorated in underglaze blue,
indicating details of faces and garments, with scroll
borders. The reverse plain. Shallow foot rim and
unglazed base.
H: 17.3cm W: 10.5cm
Late 16th century
1978.1998

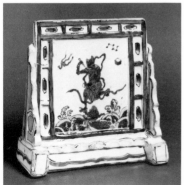

28 Table screen

Large rectangular table screen with a border of raised
perforated rectangles. Decorated in underglaze blue with
two tiny figures in a mountain landscape on one side, and
Kuixing, God of Literature, treading on a dragon in waves
on the other; borders of blue. Flat unglazed base.
H: 21.5cm W: 21.8cm
Early 17th century
1978.852

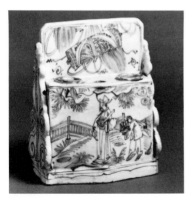

29 Brush-holder screen

Desk screen with three-holed brush holder on one side and, on the other, the dancing figure of Kuixing modelled in high relief. Decorated in underglaze blue with the details of the modelled figure picked out against clouds and waves; on the brush-holder side, an official with an attendant in a landscape; borders of blue. Slightly recessed unglazed base.
H: 15.8cm W: 12.5cm
Late 16th–early 17th century
1978.848

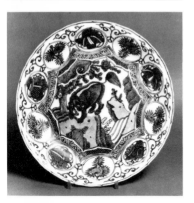

30 Brush-holder screen

Desk screen with three-holed brush holder on one side and, on the other, modelled in high relief, the figure of Kuixing, treading on a monster's head. Decorated in underglaze blue with a background of cloud scrolls and waves; on the brush-holder side, a peacock among peonies and chrysanthemums and a kylin; borders of blue. Slightly recessed unglazed base.
H: 16cm W: 11.7cm
Late 16th–early 17th century
1978.853

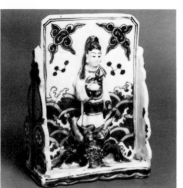

31 Dish

Large dish with everted decagonal foliate rim, thickened at the edge. Decorated in underglaze blue with a kylin pawing and roaring on a rock beneath a tree; a border of ten peach-shaped medallions alternately framing emblems and flowers; outside, panels with a repeated geometric motif. Low sloping foot ring; glazed base, no mark.
H: 5.6cm D: 35.1cm Ft.D: 19.2cm
Early 17th century
1978.884

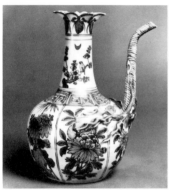

32 Ewer

Tall-necked ewer with lobed body, petalled rim, and spout modelled and decorated like a twig, with leaf sprays spreading back over the body. Densely decorated in underglaze blue in pencil style, with a bird on a prunus branch on either side of the neck, a panel of flowering plants on each lobe of the body, bands of leaf motif and key-fret pattern. Recessed glazed base; no mark.
H: 19.5cm D: 12.8cm Ft.D: 8cm
Late 16th century
1978.1935

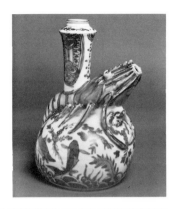

33 Kendi
Tall-necked *kendi* modelled in the form of a crayfish. Densely decorated in underglaze blue with fish among rocks and waterweed; panels on the neck filled with *ruyi* and scale motif. Slightly concave unglazed base.
H: 22.5cm D: 14.9cm Ft.D: 10.6cm
Late 16th century
1978.1936

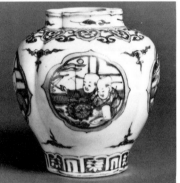

34 Jar
Oval jar in four lobes. Decorated in underglaze blue with quatrefoil panels, each with two boys playing in a garden; encircling bands of *ruyi* lappets and lotus panels. Recessed glazed base, no mark.
H: 14.5cm D: 13.4cm Ft.D: 7.3cm
Late 16th century
1978.1939

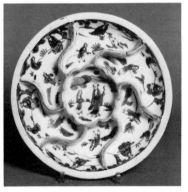

35 Compartmented dish
Dish with six curved divisions around a central well; rim unglazed to take a cover. Decorated in underglaze blue, each compartment with scholars and attendants in a landscape; outside, a continuous landscape with figures; bands of flowers and insects on the dividing walls, floral diaper at foot. Broad low foot ring; base glazed, with a six-character mark of Wanli in a double circle.
H: 4.8cm D: 23.2cm Ft.D: 16.6cm
Late 16th–early 17th century
1978.2038

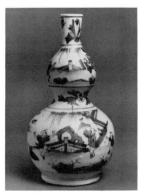

36 Double-gourd vase
Double-gourd bottle vase with thickened rim. Decorated in underglaze blue with a scholar and attendant in a landscape on the upper bulb; on the lower bulb, boys playing on a terrace with a rock wall and clouds, stylised tulip sprays on the neck, floral meanders at the waist. Low, rather thick, uneven foot ring; base glazed, no mark. (Monochrome plate p. 30)
H: 27.5cm D: 15.3cm Ft.D: 10cm
1620–1640
1978.2062

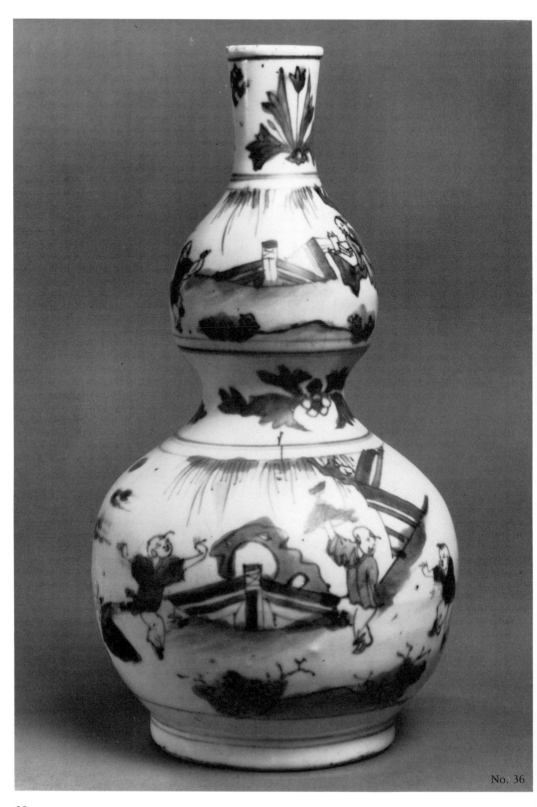

No. 36

37 Bowl

Tea bowl decorated in underglaze blue and overglaze red and green enamels. Two panels with scholars in a landscape in underglaze blue, two between in red and green, with an inscription and a vase of leaves. Slightly spreading foot ring, with a flat, rather thick, rim; unglazed base.
H: 8.2cm D: 9.2cm Ft.D: 6cm
1620–1640
1978.1112

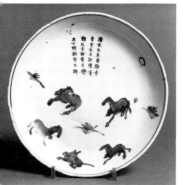

38 Dish

Saucer dish decorated in underglaze blue, with five horses pawing and leaping among grass; a moon above, and a twenty-eight-character poem. Outside, four roughly-drawn curlicues. Low foot ring; slightly convex glazed base, no mark.
H: 4cm D: 20.9cm Ft.D: 12.8cm
1630–1640
1978.2037

39 Vase

Tall beaker vase with flaring rim and swelling middle section. Decorated in underglaze blue and overglaze red, green, yellow, aubergine and brown enamels. Upper section, a warrior on horseback with bannermen and attendants, followed by a lady in a chariot, in a landscape; flower sprays on middle and lower sections; stonewall pattern at rim. Flat unglazed base.
H: 50.2cm D:21.5cm Ft.D: 17cm
1660–1675
1978.1223

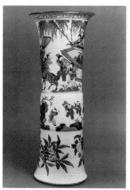

40 Vase

Tall beaker vase with flaring brown-edged rim and swelling middle section. Decorated in underglaze blue and overglaze red, green, yellow, aubergine, brown and black enamels. Upper section, a scholar on horseback, with attendants, looking up at a lady on a balcony (cf Nos 91, 102); middle section, boys playing in a garden; lower section, two large fruit sprays; stonewall pattern at rim. Flat unglazed base.
H: 51cm D: 21.5cm Ft.D: 17cm
1660–1675
1978.1807

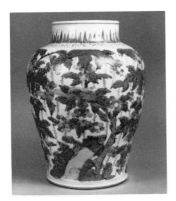

41 Jar

Large jar with wide neck and high shoulder. Decorated in underglaze blue and overglaze red, green, yellow, brown and aubergine enamels, with a dense design of tree vines, tree rats climbing among the branches. Flat unglazed base.
H: 32.2cm D: 24cm Ft.D: 17cm
1675–1690
1978.989

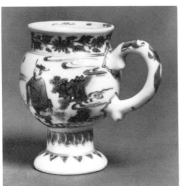

42 Mustard pot

Mustard pot with handle, rim unglazed to take a cover. Decorated in underglaze blue with an attendant presenting a hat to an official, in a landscape with rocks and banana palm; encircling bands of floral meander, curved lappets and formal leaf ornament. Tall foot; convex glazed base, no mark.
H: 12cm D: 9cm Ft.D: 6.5cm
1645–1665
1978.821

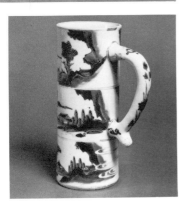

43 Tankard

Tall cylindrical tankard with handle, the rim unglazed to take a cover. Decorated in underglaze blue with three encircling zones containing landscapes with pavilions, rocks and trees among mountains by a lake. Base very slightly concave, unglazed.
H: 20cm D: 8.2cm
1645–1665
1978.795

44 Tankard with silver-gilt mounts

Tall cylindrical tankard with handle. Decorated in underglaze blue with a lady, her attendant holding a fan, and a small boy, in a garden; floral borders at rim and foot. Recessed glazed base, no mark. Silver-gilt mounts: European, late seventeenth century.
H: 23.5cm D: 9.7cm
1645–1665
1978.801

45 Jar with silver mounts

Tall jar of square section with stepped shoulder and narrow neck. Decorated in underglaze blue with gentlemen in a landscape, bordered by flower scroll, with bands on the shoulder, of leaf scroll, flower and leaf, and lappets. Flat unglazed base. The neck fitted with a silver top which unscrews: Dutch, late seventeenth century.
H:31.4cm W: 11.2cm
c. 1665
1978.863

46 Tankard with silver mounts

Tall cylindrical tankard with handle. Decorated in underglaze blue with a scholar and attendant in a landscape; borders of flowers and leaves, and lappets. Slightly concave base, glazed only in the very centre. Silver mounts: possibly provincial Swedish, eighteenth century.
H: 22.6cm D: 8.2cm Ft.D: 10.3cm
1645–1665
1978.802

47 Tankard with silver mounts

Tall cylindrical tankard with handle. Decorated in underglaze blue with two scholars and an attendant carrying luggage, in a landscape by a city wall; borders of flowers and of wave pattern. Flat unglazed base. Silver mounts: European, nineteenth century.
H: 25cm D: 7.8cm Ft.D: 9.8cm
1645–1665
1978.803

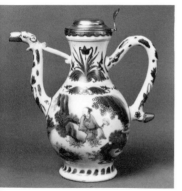

48 Ewer with silver mounts

Ewer with curving handle and spout. Decorated in underglaze blue with a scholar and pupil seated in a landscape; 'tulip' sprays on the neck, and bands of floral meander and lappets. Spreading foot; slightly concave glazed base, no mark. Silver mounts: possibly provincial German, late eighteenth century.
H: 19.5cm D: 11.1cm Ft.D: 7.6cm
1645–1665
1978.1938

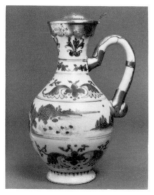

49 Ewer with silver mounts

Tall-necked ewer with curving handle and spouted rim. Decorated in underglaze blue with encircling bands of formal floral ornament of European style, and a landscape with pavilions and trees. Spreading hollow foot, glazed inside; no mark. Silver mounts: possibly provincial German, late eighteenth–nineteenth century.
H: 24cm D: 13.2cm Ft.D: 7.5cm
1645–1665
1978.1978

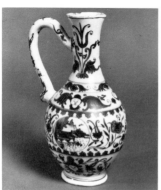

50 Ewer

Tall-necked ewer with curving handle and spouted rim. Decorated in underglaze blue with encircling bands of formal floral and arabesque ornament with masks, of European style, and in the central zone two medallions with landscapes. Spreading foot; recessed glazed base, no mark.
H: 23.3cm D: 12.1cm Ft.D: 6.8cm
1645–1665
1978.792

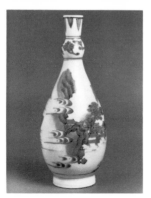

51 Vase

Bottle vase with bulb neck and slender pear-shaped body. Decorated in underglaze blue with a lakeside landscape, rocks and swirling clouds; flag ornament and lotus scrolls on the neck. Straight foot; recessed glazed base, no mark.
H: 20.7cm D: 8.6cm Ft.D: 5.5cm
1670–1680
1978.1178

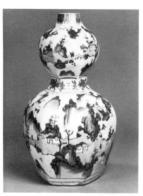

52 Double-gourd vase

Large double-gourd vase of hexagonal section, the lip cut down. Decorated in underglaze blue with a mountainous landscape, pavilions, trees and small figures covering both upper and lower bulbs; encircling bands of flag ornament and floral meanders. Slightly concave unglazed base.
H: 43.7cm D: 24.5cm Ft.D: 16.5cm
Late 17th century
1978.921

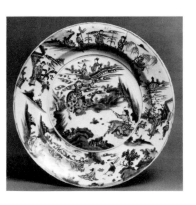

53 Dish

Large deep dish with flat everted rim. Decorated in underglaze blue with mounted warriors fighting with swords and spear, and three figures in the background; round the rim, groups of scholars and attendants in landscape; outside, sprays of prunus, pine and bamboo. Low sloping foot ring; slightly convex glazed base, no mark.
H: 8.4cm D: 49cm Ft.D: 27cm
1700–1720
1978.2066

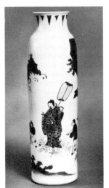

54 Vase

Cylindrical vase with everted rim; incised lines at rim and foot. Decorated in underglaze blue with a boy bowing before an official with two attendants, illustrating the story of Kongrong and the peaches. Flat unglazed base.
H: 27.6cm D: 8.3cm Ft.D: 7.6cm
1675–1690
1978.2032

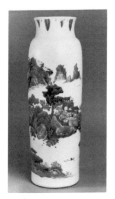

55 Vase

Tall cylindrical vase with incised lines at rim, shoulder and foot. Decorated in underglaze blue and overglaze green, red and aubergine enamels, two shades of green predominating: a mountainous landscape with temples, pavilions and small figures. Flat unglazed base.
H: 46.3cm D: 15.9cm Ft.D: 13.3cm
1680–1700
1978.1806

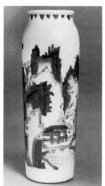

56 Vase

Tall cylindrical vase with incised bands at shoulder and foot. Decorated in underglaze blue with a mountainous landscape, small figures, pavilions, waterfalls and swirling clouds. Flat unglazed base.
H: 42.5cm D: 14.9cm Ft.D: 12.3cm
1690–1705
1978.2057

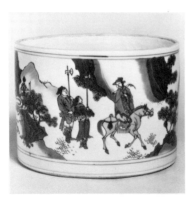

57 Brush pot
Wide cylindrical brush pot with unglazed rim. Decorated in underglaze blue with monks by a temple, an official approaching on horseback, followed by two soldiers. Slightly recessed unglazed base.
H: 13.7cm D: 20.3cm
1675–1690
1978.1986

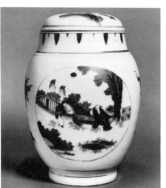

58 Jar with cover
Large ovoid jar with domed cover. Decorated in underglaze blue, on the cover and in two panels on either side of the body, with scholars on a terrace, one with an attendant bearing a tray; cloud scrolls between the panels. Straight foot; recessed glazed base, no mark.
H: 25.9cm D: 21.1cm Ft.D: 12.6cm
1675–1690
1978.2093

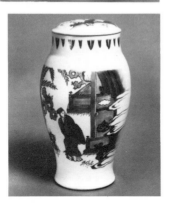

59 Jar with cover
Ovoid jar with slightly domed cover; incised bands at rim, shoulder and foot. Decorated in underglaze blue with a scene from the drama *Xixiang Ji*. On the cover, a figure holding a *lingzhi* fungus in a landscape. Narrow spreading foot, stepped foot rim; recessed glazed base, no mark.
H: 18.4cm D: 11.4cm Ft.D: 7.1cm
1690–1705
1978.2006

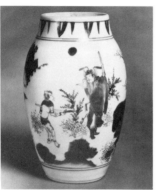

60 Jar
Ovoid jar with rim unglazed to take a cover. Decorated in underglaze blue with the Demon King surrendering his sword to Zhong Kui in a landscape. Recessed glazed base, no mark.
H: 17cm D: 11.3cm Ft.D: 6.4cm
1690–1705
1978.2010

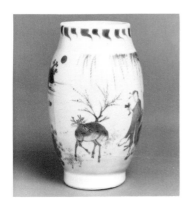

61 Jar

Ovoid jar with rim unglazed to take a cover; incised lines at rim and shoulder. Decorated in underglaze blue with the Immortal Han Xiangci in a landscape. Straight foot; recessed glazed base, no mark.
H: 17.3cm D: 10.6cm Ft.D: 6.8cm
1675–1690
1978.2028

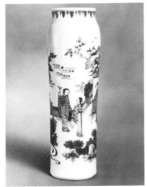

62 Vase

Cylindrical vase with turned-in neck; incised bands at shoulder and foot. Decorated in underglaze blue with a scene from the drama *Xixiang Ji*: a scholar with a monk by a pavilion watches a lady and her maid in a garden. Slightly concave unglazed base.
H. 29.2cm D: 9cm Ft.D: 8.5cm
1675–1690
1978.2036

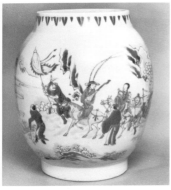

63 Jar

Large ovoid jar with rim unglazed to take a cover; incised bands at rim, shoulder and foot. Decorated in underglaze blue with a scene from the drama *Hangong Qiu*: riders, attendants and soldiers in a snowy landscape approaching a river. Straight foot and recessed glazed base, no mark.
H: 24.4cm D: 22.1cm Ft.D: 13.6cm
1690–1705
1978.943

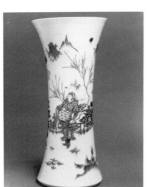

64 Vase

Tall beaker vase with flaring rim; incised bands at rim and foot. Decorated in underglaze blue with a warrior and two attendants, and an Immortal seated on a kylin in the sky. Spreading foot cut in to a flat unglazed base.
H: 43.2cm D: 20.7cm Ft.D: 18cm
1675–1690
1978.2058

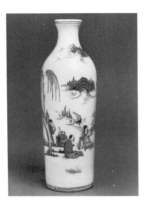

65 Vase

Small vase of European bottle shape. Decorated in underglaze blue with two scholars playing chequers by a lake and a man on a horse galloping towards them. Flat unglazed base. (Monochrome plate p. 39)
H: 23.5cm D: 8.3cm Ft.D: 6.9cm
1675–1690
1978.797

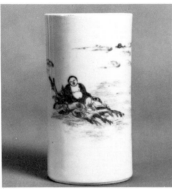

66 Brush jar

Small cylindrical brush jar; incised bands at rim and foot. Decorated in underglaze blue with the Immortal Zhang Qian floating on a tree trunk on a river. Flat unglazed base.
H: 14cm D: 7.5cm
1675–1690
1978.2002

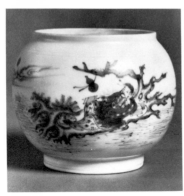

67 Jar

Small globular jar with rim unglazed to take a cover; incised bands at rim and foot. Decorated in underglaze blue with the Immortal Zhang Qian floating on a tree trunk on a river. Straight foot; recessed glazed base, no mark.
H: 9.4cm D: 11.8cm Ft.D: 7.3cm
1675–1690
1978.2013

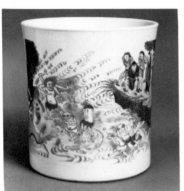

68 Brush jar

Large cylindrical brush jar; incised bands at rim and foot. Decorated in underglaze blue with demons in a river, being quelled by the Immortal Xu Xun among figures on the river bank. Flat base, glazed only in the very centre.
H: 21cm D: 20.5cm Ft.D: 18.5cm
1690–1705
1978.2056

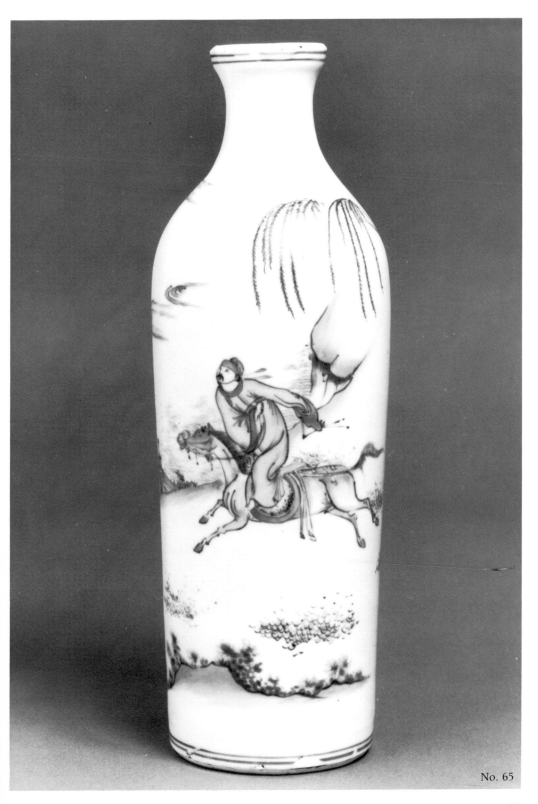

No. 65

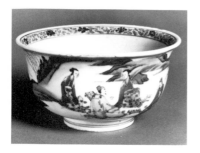

69 Bowl
Bowl with everted rim. Decorated in underglaze blue: inside, a medallion with a scholar in a landscape, and bands of fine floral scroll; outside, scholars and ladies playing chequers in a landscape. Straight foot with very wide foot rim sloping inwards to a shallow central recession; unglazed base.
H: 7.9cm D:15.3cm Ft.D: 6.6cm
1675–1690
1978.1163

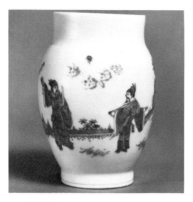

70 Brush washer
Small cylindrical brush washer on three low feet. Incised decoration covers the outside, apart from five medallions, which are decorated in underglaze blue with phoenixes and cloud scrolls. Slightly concave unglazed base.
H: 7.6cm D: 10.5cm
1690–1705
1978.2014

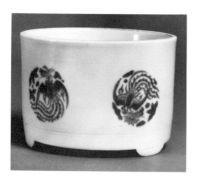

71 Jar
Ovoid jar with rim unglazed to take a cover; incised bands at rim and foot. Decorated in underglaze blue with two officials on a terrace. Straight foot; recessed glazed base, no mark.
H: 14cm D: 10.2cm Ft.D: 6.2cm
1690–1705
1978.890

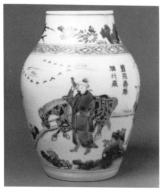

72 Jar
Jar with tapering neck, the rim unglazed to take a cover. Decorated in underglaze blue and overglaze red, yellow, green, aubergine and black enamels: a man with a hawk on his wrist leading a horse, followed by two attendants with dead game and a hound; an inscription above. Slightly concave unglazed base.
H: 16.7cm D: 12.8cm Ft.D: 7.3cm
1660–1675
1978.1493

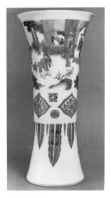

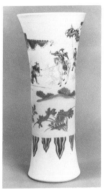

73 Vase

Tall beaker vase with flaring rim; incised lines encircling rim, foot and middle section. Decorated in underglaze blue in three registers: figures in a landscape approaching a pavilion, and a poem of twenty-eight characters with a date corresponding to 1699; lozenge panels with geometric motifs; descending lappets. Slightly concave unglazed base. (Monochrome plate p. 42)
H: 46cm D: 21.7cm Ft.D: 16.7cm
1699
1978.1276

74 Vase

Tall beaker vase with flaring rim; incised lines encircling rim, foot and middle register. Decorated in underglaze blue in three registers: four soldiers kneeling before a warrior on horseback attended by a bannerman, in a landscape divided by rocks and swirling cloud; flowering sprays of lotus, peony and prunus; descending flags. Flat unglazed base.
H: 44cm D: 19cm Ft.D: 14cm
1690–1705
1978.2035

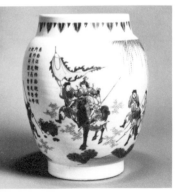

75 Jar

Large ovoid jar with rim unglazed to take a cover; incised lines at rim, shoulder and foot. Decorated in underglaze blue with a warrior on horseback, and five soldiers with spears and a banner; a poem of twenty-eight characters above. Straight foot; recessed glazed base, no mark.
H: 25cm D: 20.5cm Ft.D: 12.5cm
1690–1705
1978.1987

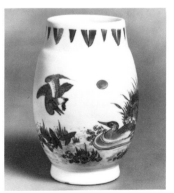

76 Jar

Ovoid jar with rim unglazed to take a cover; incised lines at rim, shoulder and foot. Decorated in underglaze blue with ducks flying and swimming on a pond, with various water plants and a peony growing beside rocks. Small foot ring; glazed base, no mark.
H: 16.5cm D: 11.1cm Ft.D: 7.3cm
1690–1710
1978.889

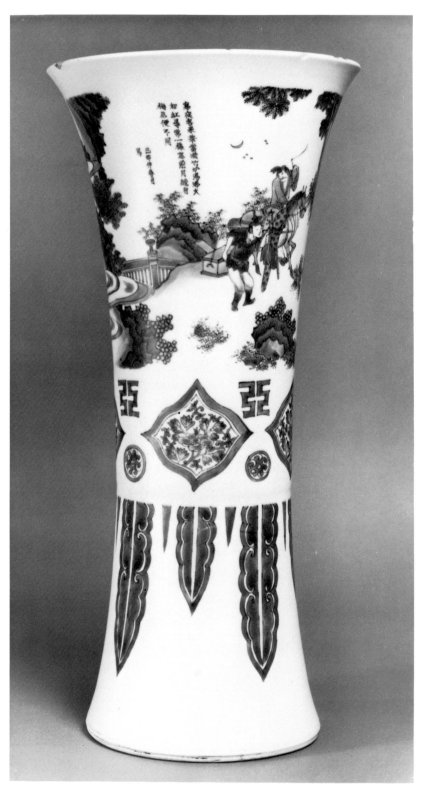

No. 73

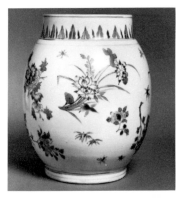

77 Jar
Large ovoid jar with rim unglazed to take a cover.
Decorated in underglaze blue and overglaze red, green,
yellow, aubergine and brown enamels, with scattered
sprays of various flowers, and insects on the wing.
Straight thick foot ring; glazed base, no mark.
H: 25.8cm D: 21cm Ft.D: 13.4cm
1675–1690
1978.1066

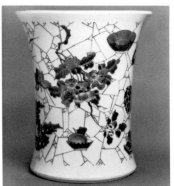

78 Jar
Large jar with flaring rim; incised lines at rim and foot.
Decorated in underglaze blue with flower sprays, emblems
and rocks against a background of cracked-ice pattern.
Flat unglazed base with stepped rim.
H: 24.5cm D: 21.2cm Ft.D: 15.5cm
1690–1710
1978.2092

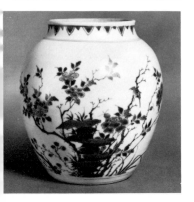

79 Jar
Large ovoid jar with short neck, the rim unglazed to take
a cover. Decorated in underglaze blue with peony, prunus
and bamboo plants growing from a rock, and birds
perching and flying. Slightly concave unglazed base.
H: 22.7cm D: 21.5cm Ft.D: 12cm
1690–1710
1978.2094

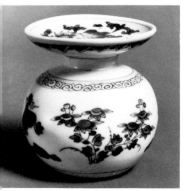

80 Jar
Small leys jar with wide saucer rim. Decorated in
underglaze blue with sprays of chrysanthemum,
pomegranate and convolvulus; floral meanders on the rim.
Recessed glazed base, with the edge unglazed forming the
foot rim; no mark.
H: 10.2cm D: 9.7cm Ft.D: 5.2cm
1690–1710
1978.953

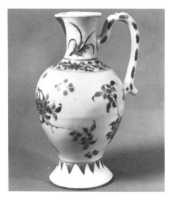

81 Ewer

Ewer with spouted rim and loop handle. Decorated in underglaze blue with sprays of flowers and leaves. Spreading hollow foot, glazed inside; no mark.
H: 22.5cm D: 12.3cm Ft.D: 8.8cm
1675–1690
1978.2026

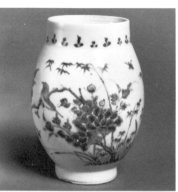

82 Jar

Ovoid jar with wide neck, the rim unglazed to take a cover; incised bands at rim, shoulder and foot. Decorated in underglaze blue with peony and bamboo plants growing from a rock, a perching bird, insects and a butterfly on the wing. Small straight foot; recessed glazed base, no mark.
H: 15.2cm D: 11.3cm Ft.D: 6.2cm
1690–1705
1978.806

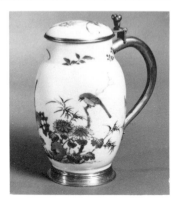

83 Jar with cover and silver mounts

Ovoid jar mounted in silver as a tankard. Incised lines encircle cover, rim and shoulder. Decorated in underglaze blue: on the cover, a flowering lotus growing by water; leaf sprays on the neck; on the body, chrysanthemum and bamboo plants growing from rocks, with birds perching and flying. Straight foot; recessed glazed base, no mark. Silver mounts: European, seventeenth–eighteenth century.
H: 18cm D: 10.5cm Ft.D: 8cm
1690–1705
1978.796

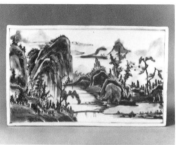

84 Screen tile

Rectangular screen tile, luted together in hollow sections, with rectangular openings on each edge. Decorated on one side in underglaze blue with a lakeside mountain landscape, and on the other in overglaze red, green, aubergine and yellow enamels with a peony spray and a butterfly. (Monochrome plate p. 45 and cover)
H: 16.2cm L: 27cm Depth: 3.7cm
1690–1710
1978.1174

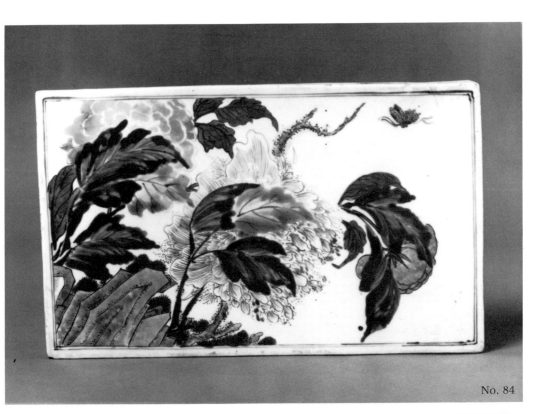

No. 84

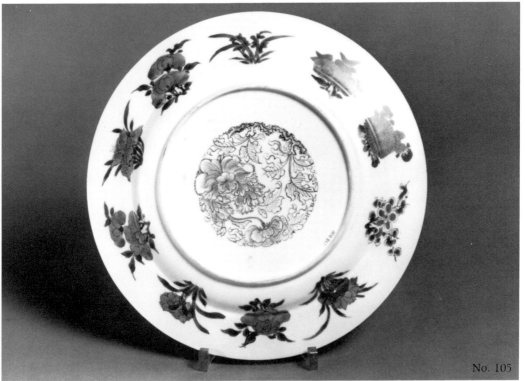

No. 105

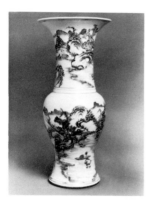

85 Vase

Baluster vase with tall flaring neck. Decorated in underglaze blue with mountain landscapes and lakeside scenes with figures. Spreading foot; recessed glazed base with a double blue circle, but no mark.
H: 45.1cm D: 18.4cm Ft. D: 15.2cm
1690–1705
1978.2055

86 Vase

Vase with short cylindrical flaring neck and wide shoulder. Decorated in underglaze blue with a lakeside mountain landscape; bamboo sprays on the neck above a diaper band. Low foot ring with a ridged rim; glazed base, no mark.
H: 19.3cm D: 8.3cm Ft.D: 6.1cm
1690–1710
1978.830

87 Vase

Vase of slender pear shape. Decorated in underglaze blue and red: on one side, a lobed panel containing a landscape with small figures; on the other, lotus flowers in a vase. Stepped foot rim; recessed glazed base, no mark.
H: 18.5cm D: 8.3cm Ft.D: 5cm
1690–1710
1978.2029

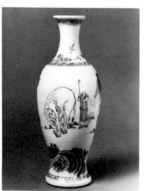

88 Vase

Bottle vase with narrow flaring neck. Decorated in underglaze blue with two monks and an elephant in a rocky landscape; chrysanthemum spray and bamboo on the neck, and bands of diaper. Spreading foot with stepped rim; recessed glazed base with a mark, *qing wan*, within a double circle.
H: 21.8cm D: 8.7cm Ft.D: 6cm
1690–1710
1978.2030

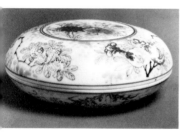

89 Box with cover
Round ink box with shallow domed cover. Decorated in underglaze blue and red: on the cover, a lotus plant within a medallion surrounded by sprays of pomegranate and lichee; on the sides of the bowl, chrysanthemum and grape vine. Inside glazed. Slightly concave unglazed base.
H: 4.8cm D:13.2cm Ft.D: 7.4cm
1690–1710
1978.1166

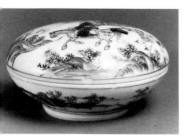

90 Box with cover
Round ink box with domed cover. Decorated in underglaze blue and red: on the cover, a scholar riding a horse, with an attendant; on the bowl, a continuous landscape with mountains and a lake. Inside glazed. Low foot ring; glazed base, no mark.
H: 6.7cm D: 13.7cm Ft.D: 7.5cm
1690–1710
1978.851

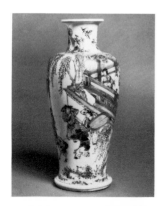

91 Vase
Vase with cylindrical flaring neck and wide shoulder. Decorated in underglaze blue with a scholar on horseback, and attendants, looking back at a lady on a balcony (cf Nos 40, 102). Spreading foot with grooved rim; glazed base, no mark. (Colour plate I)
H: 25.5cm D: 11.7cm Ft.D: 8.9cm
1690–1710
1978.1996

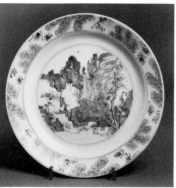

92 Dish
Saucer dish with flat everted rim. Decorated in underglaze blue with a central medallion containing a mountain landscape, with pavilions and a fisherman on a lake; a border of pine branches and blobby dots on the rim; outside, three bamboo sprays. Low sloping foot ring; base glazed, with a four-legged incense burner mark in a double circle.
H: 3cm D: 20.3cm Ft.D: 12cm
1690–1710
1978.842

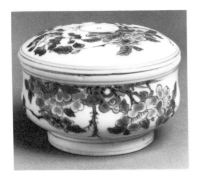

93　Pot pourri holder
Bowl with everted rim, and cover of flattened dome shape with a central vent piereced in the form of a character, *xiang*, 'fragrance'. Decorated in underglaze blue with peony sprays and bamboo growing from rocks. Straight foot ring; heavy base, glazed, with a six-character mark of Chenghua in a double circle.
H: 6.8cm D: 10.5cm Ft.D: 7.1cm
1680–1700
1978.2012

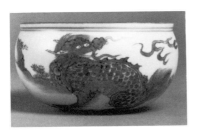

94　Bowl
Bowl with thickened brown-edged rim and deeply curved sides. Decorated in underglaze blue with a kylin sitting in a landscape with rocks, swirling clouds and banana palm. Inside plain. Very small, slightly recessed, unglazed base with vestigial foot rim.
H: 7.4cm D: 13.5cm Ft.D: 4.5cm
1680–1700
1978.1842

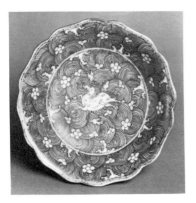

95　Dish
Small saucer dish with everted brown-edged rim moulded in four lobed petals. Decorated inside and out, with whorled waves in underglaze blue, against which are reserved white blossom and wave crests, and a leaping horse in the centre. Small straight foot ring; base glazed, with a six-character mark of Jiajing in a double circle.
H: 4.1cm D: 15.5cm Ft.D: 6.4cm
1680–1700
1978.829

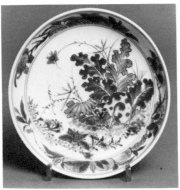

96　Dish
Small saucer dish with almost vertical sides, decorated in underglaze blue: inside, a medallion with a cat crouching among leafy plants, a butterfly in its mouth, and a border of fruit sprays; outside, sprays of narcissus, cherry and bamboo. Small straight foot ring; wide heavy base, glazed, with a six-character mark, *wenrun jingu zhenshang*.
H: 4.4cm D: 16.2cm Ft.D: 7.3cm
1680–1700
1978.819

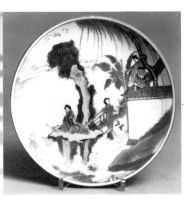

97 Dish

Saucer dish with brown-edged rim. Decorated in underglaze blue with a scene from the drama *Xixiang Ji*: a gentleman climbing over a wall to a lady in a garden. Small foot ring; very heavy base, glazed, with a six-character mark of Jiajing in a double circle.
H: 5cm D: 21.3cm Ft.D: 8.2cm
1680–1700
1978.838

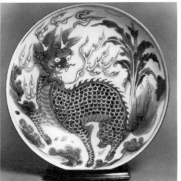

98 Dish

Large saucer dish with brown-edged rim. Decorated in underglaze blue with a large kylin pawing and breathing fire, by a banana palm in a landscape of rocks. Outside plain. Low sloping foot ring; slightly convex glazed base with a mark, *yu tang wu yu*, in a double circle.
H: 8.3cm D: 35cm Ft.D: 17.5cm
1680–1700
1978.888

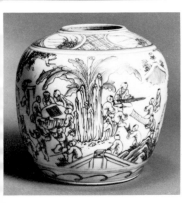

99 Jar

Jar of flattened ovoid form with cut-down neck. Decorated in underglaze blue, possibly in preparation for overglaze *doucai* colours: children playing various games in a garden; on the shoulder, oval panels containing leaves growing from rocks, on a diaper ground. Thick foot rim; slightly recessed convex base, glazed but for a patch in the centre. No mark.
H: 17.5cm D: 18.6cm Ft.D: 12.7cm
1690–1710
1978.1994

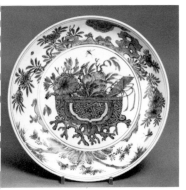

100 Dish

Large dish with very slightly everted rim. Decorated in underglaze blue with a bowl on a root stand, containing sprays of peach, peony and pomegranate, and a scroll bound with ribbons. On the sides, a border of flowering branches and bamboo growing from rocks. Outside, two sprays of iris. Low rounded foot rim and slightly convex glazed base with a mark, *zhen ying chuan ji*, in a double circle.
H: 7.1cm D: 35cm Ft.D: 21.4cm
Early 18th century
1978.1956

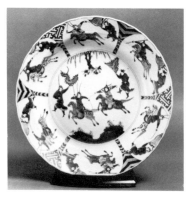

101 Dish

Large dish with flat everted rim, the edge slightly lobed. Decorated in underglaze blue with two warriors on horseback, fighting with swords, attended by bannermen. On the sides, six panels with similar figures, against a diaper ground. Outside, flowering branches on the rim and *ruyi*-head motifs in panels on the sides. Low sloping foot ring; heavy base, glazed, with a six-character mark of Chenghua in a double circle.
H: 6.8cm D: 34.6cm Ft.D: 19.3cm
Early 18th century
1978.974

102 Dish

Large saucer dish with everted rim. Decorated in underglaze blue with a scholar on horseback, with attendants, pointing up at a lady on a balcony (cf Nos 40, 91). Low foot ring, glazed base with an artemesia leaf mark.
H: 4.5cm D: 41.5cm Ft.D: 24.5cm
1690–1710
1978.973

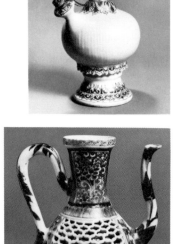

103 Kendi with silver mounts

Tall-necked *kendi* with moulded ribbed body, and a lobed fringe overhanging a tall stepped foot. Decorated in underglaze blue with bands of formal leaf, lappet and flame pattern at shoulder, spout and foot. The spreading foot deeply recessed, glazed inside, leaving a thick unglazed foot rim; no mark. Silver mounts: probably Indian, eighteenth century.
H: 28.8cm D: 14.5cm Ft.D: 11.2cm
1700–1720
1978.909

104 Ewer

Small ewer with long handle and spout, and double body, the outer layer pierced (*ling lung*). Decorated in yellow enamel, with underglaze blue floral scrolls and sprays, bands of ascending leaf and diaper on both outer and inner body. Low foot ring; glazed base pierced with five small holes; no mark.
H: 15.8cm D: 9.8cm Ft.D: 5.7cm
1690–1710
1978.1170

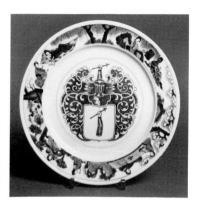

105　Plate

Plate with flat everted rim. Decorated in underglaze blue with an armorial crest in the centre, and on the rim, a border of ladies in a garden. Outside, ten different flower sprays. Low narrow foot ring; base glazed, with large finely pencilled peony mark. (Monochrome plate p. 45)
H: 2.4cm D: 25.2cm Ft.D: 14.1cm
Early 18th century
1978.867

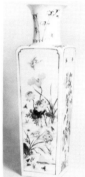

106　Vase

Tall vase with body of square section and cylindrical flaring neck. Decorated in underglaze blue, red and pale grey, with celadon glaze moulded in shallow relief: on each side of the body, panels with flowers, birds and insects; flower sprays at the shoulder, bamboo on the neck. Flat unglazed base; a small square glazed recession in the centre, with a six-character mark of Kangxi.
H: 49.8cm W: 14.8cm Ft.W: 11.5cm
Early 18th century
1978.1222

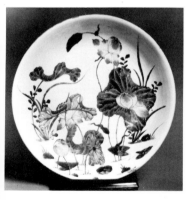

107　Dish

Large saucer dish with everted rim. Decorated in overglaze enamels in the *famille verte* palette, with lotus flowers and other water plants growing in a pond. Outside plain. Low foot ring with wide groove; base glazed, with an artemesia leaf mark in a double circle.
H: 6.6cm D: 34.7cm Ft.D: 20cm
Early 18th century
1978.1031

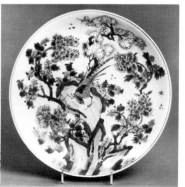

108　Dish

Large saucer dish with everted rim. Decorated in underglaze blue with a pheasant on a rock among magnolia and peony trees; outside, two bamboo sprays. Low sloping foot ring; glazed base with a six-character mark of Chenghua in a double circle.
H: 4.1cm D: 27cm Ft.D: 15.5cm
Early 18th century
1978.2039

217986

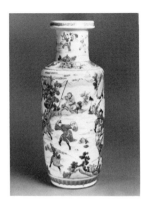

109 Vase

Large vase with saucer rim, cylindrical neck and square shoulder. Decorated in overglaze red, blue, green, yellow, aubergine and black enamels, with skirmishing warriors and a bannerman in a rocky landscape; on the neck, three boys in a landscape; bands of floral and diaper ornament. Low thick foot ring; base glazed, with a double circle but no mark.
H: 43.8cm D: 18.1cm Ft.D: 13cm
1710–1720
1978.1081

110 Screen tile

Rectangular screen tile, luted together in hollow sections, with rectangular openings on each edge. Decorated in overglaze red, green, yellow, brown and black enamels. On one side, a scholar at his desk, dreaming of himself with a girl; on the other, chrysanthemums growing from a rock; diaper borders.
H: 16.2cm L: 22.8cm Depth: 3.8cm
Early 18th century
1978.1175

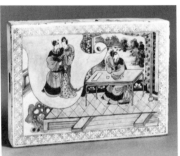

111 Screen tile

Rectangular screen tile, luted together in hollow sections, with rectangular openings on each edge. Decorated on one side in overglaze red, blue, green, yellow and black enamels, with a spray of iris, waterplants, and a butterfly; the other side, moulded in shallow relief with peonies and arabesques under a pale celadon glaze.
H: 23.3cm L: 34cm Depth: 4.7cm
Early 18th century
1978.2095

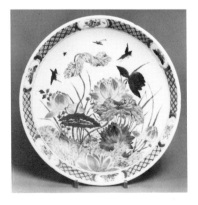

112 Dish

Large saucer dish with everted rim. Decorated in overglaze red, blue, green, yellow, aubergine and black enamels with a little gold, with lotus plants and two kingfishers; on the rim, panels with butterflies, against a border of diaper; outside, three flower sprays. Low foot ring with wide groove; base glazed, with a pseudo seal mark in a double circle.
H: 5.9cm D: 34.5cm Ft.D: 19.7cm
Early 18th century
1978.1072

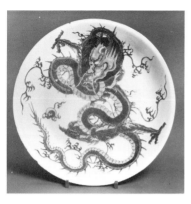

113 Dish

Large saucer dish with everted rim. Decorated in overglaze red, blue, green, yellow and aubergine enamels with a little gold, with a four-clawed dragon chasing a fiery pearl. Outside plain. Low foot ring with wide groove; base glazed, with an artemesia leaf mark in a double circle.
H: 6.4cm D: 34.8cm Ft.D: 20cm
1720–1750
1978.1505

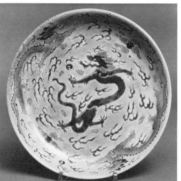

114 Dish

Saucer dish with everted rim. Decorated in overglaze enamels, with incised outline and detail: green and aubergine dragons chase flaming pearls among cloud scrolls on a yellow ground; outside, two dragons above a border of lappets. Low foot ring; base glazed, with a six-character mark of Kangxi in a double circle.
H: 4.3cm D: 24.8cm Ft.D: 16cm
Early 18th century
1978.1140

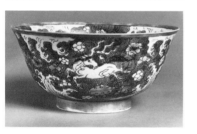

115 Bowl

Deep bowl with everted rim. Decorated inside and out in overglaze green, yellow, aubergine and black enamels, with horses prancing amid wave crests, scattered blossom and emblems, against green and black waves. Straight foot ring; base glazed, with a six-character mark of Hongzhi in a double circle.
H: 9.8cm D: 20.3cm Ft.D: 9.2cm
1720–1750
1978.1371

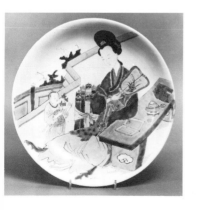

116 Dish

Large saucer dish, decorated in overglaze enamels in the *famille verte* palette, with a lady at her writing table, and an attendant. Outside plain. Low foot ring; base glazed, with a mark of two scrolls tied with a ribbon in a double circle.
H: 3.8cm D: 34.8cm Ft.D: 20.5cm
Early 18th century
1978.1169

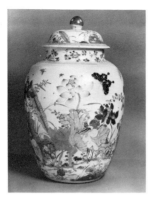

117 Jar with cover
Very large high-shouldered jar and domed cover with knob. Decorated in overglaze enamels in the *famille verte* palette with gold: water plants, cranes, ducks and butterflies. Underglaze blue lines encircle rim and foot. The base slightly concave, unglazed. (Colour plate II)
H: 57cm D: 37cm Ft.D: 22cm
c. 1720
1978.1849

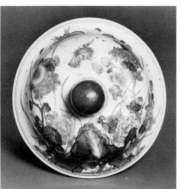

118 Cover
Domed cover with rounded knob and flaring rim, and an inner ring to fit the neck of a large jar. Decorated in underglaze blue and overglaze red, green, yellow and black enamels with gold: chrysanthemums and peonies growing from a rock, butterflies and insects on the wing; the knob blue with a gold flower design.
H: 13cm D: 26.3cm
c. 1720
1978.1278

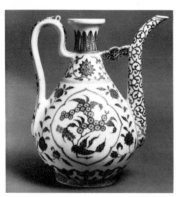

119 Ewer
Ewer with tall curving handle and bridged spout; the handle with a small loop at the top and three imitation rivet heads at the base. Decorated in underglaze blue: on each side of the body, a quatrefoil panel with a fruit spray; sprays of peony, lotus and chrysanthemum between; formal ornaments over the rest of the body. Low foot ring; unglazed base.
H: 25.5cm D: 16.6cm Ft.D: 9.9cm
1760–1780
1978.2043

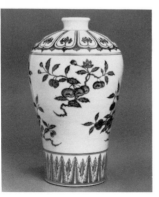

120 Vase
Vase with short narrow neck and widely rounded shoulder. Decorated in underglaze blue in three registers: a wide band of lappets on the shoulder, various fruit sprays over the body, a band of ascending leaf at the foot. Low rounded foot ring; unglazed base.
H: 30cm D: 18.2cm Ft.D: 12cm
Mid 18th century
1978.945

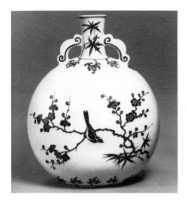

121 Pilgrim bottle

Very large pilgrim bottle with lobed handles. Decorated in underglaze blue: on each side, a bird perched on a flowering branch; leaf sprays on the neck; curling lappets at base of neck and foot. Flat unglazed base.
H: 49.5cm D: 37.5cm Ft.D: 19.5cm
c. 1730
1978.1279

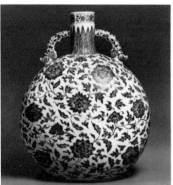

122 Pilgrim bottle

Large pilgrim bottle with cylindrical neck and moulded handles. Decorated in underglaze blue: the body covered with dense lotus and peony scroll; on the neck, ascending leaf ornament; floral scroll at rim and on handles. Low rounded foot rim, slightly concave glazed base with a six-character mark of Yongzheng in seal script.
H: 36.7cm D: 29cm Ft.D: 14.5cm
1740–1760
1978.1988

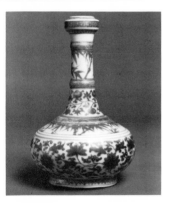

123 Vase

Long-necked bottle vase with squared bulb mouth, and three swelling rings encircling the neck. Decorated in underglaze red with horizontal bands of formal ornament, floral scrolls and bamboo sprays, separated by encircling lines in underglaze blue. Slightly flaring foot ring; glazed base, no mark.
H: 21cm D: 13.8cm Ft.D: 9cm
1740–1780
1978.1319

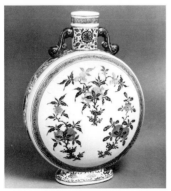

124 Pilgrim bottle

Pilgrim bottle with moulded handles, the body with squared edges. Decorated in underglaze blue and red, with sprays of peach, citrus and pomegranate on each face of the body; bands of formal flower scroll on sides and neck; borders of diaper and classic scroll. Spreading foot with thick flat rim; unglazed base.
H: 33.5cm D: 24.5cm Ft.D: 12cm
c. 1730
1978.1080

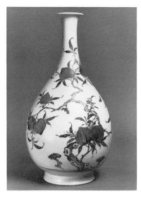

125 Vase
Large pear-shaped bottle vase with narrow flaring neck. Decorated in underglaze blue and red, with a single spreading peach tree and flying bats. Spreading foot; low foot ring; base glazed, no mark.
H: 45cm D: 24.5cm Ft.D: 14.6cm
1730–1750
1978.1028b

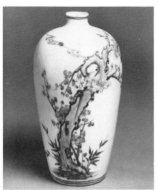

126 Vase
Vase with very small neck and wide rounded shoulder. Decorated in underglaze blue and red, with a prunus tree and two flying bats. Slightly recessed glazed base; no mark.
H: 19.5cm D: 11cm Ft.D: 6.5cm
1740–1780
1978.1375

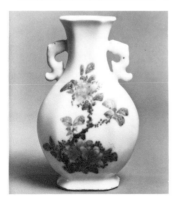

127 Vase
Vase of octagonal section with two moulded handles on the neck. Decorated in blue and red under a greenish-grey glaze, with a peony plant on one side and a chrysanthemum on the other. Spreading foot; recessed glazed base, with a seal mark of Qianlong.
H: 18cm D: 11.4cm Ft.D: 6.9cm
1740–1780
1978.1318

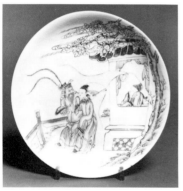

128 Dish
Large dish with slightly everted rim. Decorated in overglaze pale red and black enamels and some gold, with a scholar in a pavilion dreaming of himself as a general with a girl. Outside plain. Low foot ring; base glazed, no mark.
H: 3.7cm D: 19.5cm Ft.D: 12cm
1730–1760
1978.1845

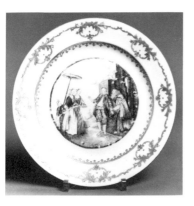

129 Plate

Plate with flat rim, decorated in overglaze pale red and black enamels with gold: in the centre, a scene from a French engraving, with two men and two ladies attended by a boy with a parasol; border of rococo scroll design in red and gold. Outside plain. Very slight foot rim; recessed glazed base, no mark.
H: 2.6cm D: 22.6cm Ft.D: 13cm
1730–1760
1978.1836

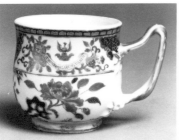

130 Cup

Small cup with moulded handle; rim unglazed to take a cover. Decorated in overglaze dark blue and red enamels with gold, in Chinese Imari style, with an armorial crest on either side, amid floral designs. Small foot ring; base glazed, no mark.
H: 5.9cm D: 6.1cm Ft.D: 3.9cm
1730–1760
1978.1334

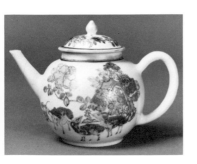

131 Teapot with cover

Small teapot with knobbed cover. Decorated in overglaze black and red enamels with much gold, with a design on either side of three rams standing beneath large peony and chrysanthemum plants; sprays of peony and chrysanthemum on the cover. Small foot ring; base glazed, no mark.
H: 11.5cm D: 10.5cm Ft.D: 6cm
Mid 18th century
1978.1951

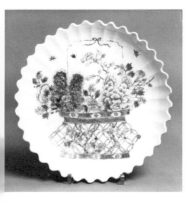

132 Dish

Saucer dish with fluted sides and scalloped rim. Decorated in overglaze red, green, yellow, aubergine and black enamels with a little gold: peony plants growing from a basket, butterflies and an insect. Outside plain. Very low sloping foot ring; base glazed, no mark.
H: 4.4cm D: 24.3cm Ft.D: 13.1cm
1720–1750
1978.1253

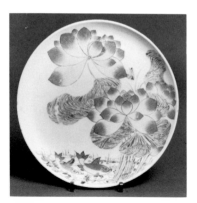

133 Dish
Shallow saucer dish, decorated in overglaze enamels in the *famille rose* palette, with lotus flowers growing in a pond, and two swimming fish. Outside plain. Low sloping foot ring; base glazed, no mark.
H: 3.1cm D: 26.3cm Ft.D: 19cm
c. 1730
1978.1214

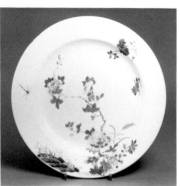

134 Dish
Large dish with flat everted rim. Decorated in overglaze enamels in the *famille rose* palette, with a peony tree, rocks and flowers, a dragonfly on the wing. Outside plain. Low sloping foot ring; base glazed, no mark.
H: 3.8cm D: 38.9cm Ft.D: 22.7cm
1730–1760
1978.1022

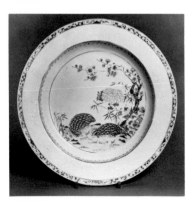

135 Dish
Large dish with flat everted rim. Decorated in overglaze enamels in the *famille rose* palette, with two quails with millet seed beneath a prunus tree, chrysanthemum and peony plants; on the rim, *pâte-sur-pâte* decoration of prunus, chrysanthemum and bamboo, between narrow borders of trefoil pattern and flowers. Outside plain. Sloping foot ring; base glazed, no mark.
H: 5.4cm D: 39.1cm Ft.D: 22.3cm
1740–1780
1978.1230

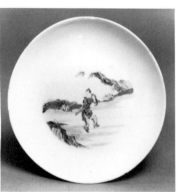

136 Dish
Small saucer dish, decorated in overglaze enamels in the *famille verte* palette, with a figure of a fisherman, carrying an oar and with a basket on his back, in a rocky landscape. Low sloping foot ring; base glazed, with a six-character mark of Chenghua in a double circle.
H: 3.5cm D: 15.8cm Ft.D: 9.5cm
c. 1750
1978.1041

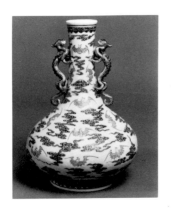

137 Vase

Vase with tall neck and two handles moulded in the form of dragons. Decorated in underglaze blue with bands of lappets, and cloud scrolls over the body with flying bats in overglaze pink enamel. Slightly spreading foot ring; base glazed, with a six-character seal mark of Qianlong.
H: 20cm D: 14.1cm Ft.D: 8.1cm
1760–1780
1978.1314

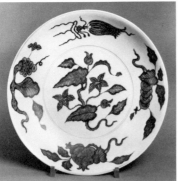

138 Dish

Saucer dish with slightly everted rim. Decorated in underglaze blue against a ground of overglaze yellow enamel, with stylised fruit sprays inside, and a wreath of flowers and leaves outside. Low sloping foot ring; base glazed, with a six-character mark of Xuande in a double circle.
H: 5cm D: 26cm Ft.D: 14.2cm
1760–1780
1978.976

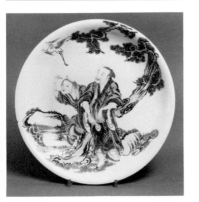

139 Dish

Large saucer dish with everted rim. Decorated in overglaze enamels in the *famille rose* palette, with a scholar and pupil among rocks beneath a pine tree, a crane flying overhead. Outside plain. Low sloping foot ring; base glazed, no mark.
H: 6cm D: 35.5cm Ft.D: 21.2cm
Mid 18th century
1978.1068

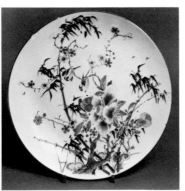

140 Dish

Large saucer dish with brown-edged rim. Decorated in overglaze enamels in the *famille rose* palette, with a pair of birds perched among peony, prunus and bamboo. Outside plain. Low sloping foot ring; base glazed, no mark.
H: 5.5cm D: 35cm Ft.D: 21.6cm
Late 18th century
1978.999

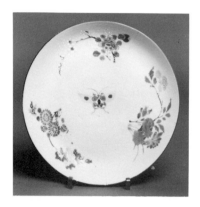

141 Dish

Saucer dish with brown-edged rim. Decorated in overglaze enamels in the *famille rose* palette, with a butterfly in the centre, surrounded by three flower sprays: peony and prunus, lotus and rose, chrysanthemum and rose. Outside plain. Low sloping foot ring; base glazed, no mark.
H: 3.7cm D: 21.9cm Ft.D: 12.8cm
Mid 18th century
1978.1890

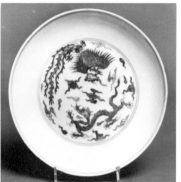

142 Dish

Saucer dish decorated in *doucai* style, in underglaze blue outline and overglaze red, yellow, green and aubergine enamels: the central medallion, with a phoenix and a five-clawed dragon among cloud scrolls; the same elements repeated outside. Low foot ring; base glazed, with a six-character mark of Chenghua in a double circle.
H: 4.1cm D: 20.3cm Ft.D: 12.7cm
Mid–late 18th century
1978.1254

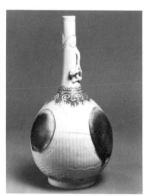

143 Vase

Vase with tall narrow neck, a coiled dragon moulded in high relief; the body moulded in shallow relief with vertical ribs and encircling ornamental bands. Decorated under a pale celadon glaze, with copper red at base of neck and in three medallions on the body. Straight foot ring; base glazed, with a six-character mark of Kangxi.
H: 31cm D: 16.3cm Ft.D: 9.5cm
Mid–late 18th century
1978.963

144 Dish

Large saucer dish covered with incised decoration under a yellow glaze: in the centre, two five-clawed dragons chasing a fiery pearl among cloud scrolls, and a border of eight different flower sprays; outside, four dragons chasing fiery pearls. Slightly sloping foot ring; base glazed yellow, with an incised six-character mark of Tongzhi.
H: 5.9cm D: 32cm Ft.D: 22cm
1862–1872
1978.1236

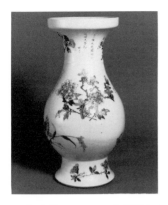

145 Vase
Large pear-shaped vase with wide saucer rim. Decorated in overglaze enamels in the *famille rose* palette, mainly black and gold, with various flower sprays, and four inscriptions in gold. Tall spreading foot with thick rounded rim; slightly recessed glazed base, no mark.
H: 39cm D: 20.5cm Ft.D: 14.5cm
19th century
1978.1377

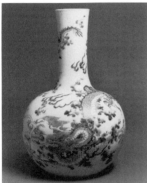

146 Vase
Vase with tall cylindrical neck and globular body. Decorated in underglaze blue and red, with a large five-clawed dragon chasing a fiery pearl among clouds. Slightly recessed glazed base, with a six-character mark of Xuande in a double circle.
H: 33cm D: 21.3cm Ft.D: 11cm
19th century
1978.1360

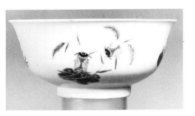

147 Bowl
Bowl with everted rim. Decorated in overglaze enamels in the *famille verte* palette outside, with four clusters of plants and various insects: dragonfly, bees, cricket, beetle and grasshopper. Inside plain. Straight foot ring; base glazed, no mark.
H: 7.5cm D: 17.5cm Ft.D: 7.7cm
Late 19th–20th century
1978.1348

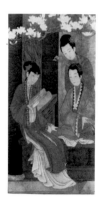

148 **Painting**
Three girls beneath a magnolia tree, one reading the classics.
Ink and colour on silk.
177cm × 90cm
20th century
1978.2555

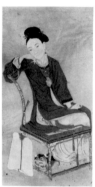

149 **Painting**
Girl seated with fan and small dog.
Ink and colour on silk.
122cm × 64cm
Probably 18th century
1978.2543

Japanese ceramics

The earliest Japanese porcelain was made at or near Arita, in the Hizen district of Kyushu, at the beginning of the seventeenth century. Initially, the wares were based on Karatsu stonewares and Korean porcelain, but soon there were links with Chinese styles. In the middle of the century, the Dutch East India Company began to buy and order Japanese porcelain for export to Europe and the Near East. Soon Chinese merchants joined in the trade; they sold Japanese porcelains to other European East India Companies at several ports in the East. This trade reached its peak in the late seventeenth and early eighteenth centuries, but continued on and off until well into the nineteenth century.

The porcelains shipped were usually decorated in underglaze blue or in overglaze enamels, or in a combination of both. These wares, made in Arita, are called in Japan *ko-Imari*, 'Old Imari', after the name of the port through which they were shipped to the main distribution port, Nagasaki. One special group of these porcelains has been called Kakiemon. In the West, we tend to call the blue and white wares Arita, and the coloured wares Imari, while also separating out the Kakiemon. This has been a classification of convenience and does not stand up to close examination, but at the time when Gerald Reitlinger was forming his collection, it was unquestioned.

The ceramics described in this catalogue are divided into somewhat loosely classificatory groups. Of these groups, the major ones are based upon the so-called Kakiemon wares. The word Kakiemon has been used as a descriptive term in various different ways. Probably the Kakiemon style was created in the third quarter of the seventeenth century by a family of enamellers, possibly ancestors of the present-day Kakiemon family, who founded a kiln towards the end of the century and became producers of a fine-bodied porcelain as well as of more ordinary pieces. Usually, today, the term refers to porcelain decorated in a certain palette of fine, soft-coloured enamels, often with no underglaze blue, in a particular style of painting. Gerald Reitlinger greatly admired the most beautifully decorated of these wares. In some ways this is a direct corollary to his love of the seventeenth-century Chinese ceramics: he particularly enjoyed seventeenth-century taste, and this was a taste for well-painted decoration upon a fine ceramic body.

For reasons of display, the blue and white pieces have been separated from the enamelled wares and labelled here Arita. This is also partly for reasons of

ignorance: we are only now beginning to be able to classify the blue and white wares. Not only can we rarely distinguish between the products of the dozen-odd Arita kilns that made export blue and white, but the known blue and white products of the Kakiemon kiln differ little from them.

Some of the problems of identification are due to the fact that all the export kilns were, ultimately, working for one patron, the Lord Nabeshima. His agents, the Taku family, and the 'office of works', the Arita *Sarayama Daikan*, presumably distributed the vast Dutch and Chinese orders between the licensed kilns. This means, of course, that not only were different qualities produced at one kiln, but also that several kilns may have been needed to complete one order for one type of ware. With enamelled pieces, the difficulty is compounded by the fact that enamelled sherds are almost never found at kiln sites. For the high-fired wares made in the *noborigama* were rarely damaged in the low-firing muffle kiln.

Although a muffle kiln has not been found in the excavation of any Arita site, there is still good reason to believe that enamelling was first done in Arita at several different workshops. This we can tell not only because wares of identical shape and size exist in varying palettes of enamels as well as in underglaze blue only, but also because of the very range of enamels used in the earlier stages of production. One of these early workshops may well have been the ancestor of the so-called Kakiemon style.

We still have little or no direct evidence for the origins of enamelled porcelain in Japan: little documentation exists, and no single piece can be proven to relate to documentary evidence until nearly the end of the seventeenth century. However, we do know that Japanese enamelled porcelain was being made in Arita at least by 1653: this is from a teamaster's reference in his diary, and not merely by tradition or from dubious later documents. From European documentary sources we know that enamelled wares were exported to Europe at least as early as 1659.

The very earliest stage of enamelling, represented here, it is suggested, by Nos 150–152, seems to have used no overglaze yellow, but did use an overglaze blue: this suggests that the colours were not imitated from the Chinese, who had an overglaze iron yellow, but no overglaze blue save in Swatow wares.

After this stage, there is an apparently experimental stage both in palette (Nos 153, 154) and in style of painting (Nos 155–157). Nos 155 and 156 are close to the group we might call proto-Kakiemon in palette, while Nos 157–159 belong to a definite sub-group that could be designated the 'blue' palette. Nos 160–164 may well represent the formation of the Kakiemon style and palette, which with its innumerable variations (Nos 167–171, 178, 179, 197, 198) was to continue until today. Two other early groups, the 'green' palette and the 'dark blue and dark red' palette, are not represented in the collection. The other *ko-Imari* wares are not at this stage sharply divided from these quasi-Kakiemon groups. Some of the *ko-Imari* sub-styles, sometimes grouped together as being in '*ko-Kutani* style', are clearly contemporary, but not sharply defined. The straightforward *ko-Imari* style and its derivatives may come a little later.

It simply is not possible that the vast quantity of Kakiemon style wares could have been produced either by one kiln or by one enamelling workshop; clearly others were involved. This causes difficulties with the definition of the Kakiemon style groups: obviously much of the porcelain included in these groups was made in other Arita kilns. It is clear that the actual Kakiemon kiln did not begin production until well into the Genroku period (1688–1703); if the Kakiemon family were the originators of the style called after them, then they were enamellers before they were potters. It is therefore a double problem: we have to identify when 'Kakiemon' enamels occur on Arita body as well as when they occur on Kakiemon kiln body. As several Arita kilns made the famous *negoshide* body, the milky-white body that is the hallmark of the best quality Kakiemon, as well as imitating Kakiemon enamels, this is a very complicated problem. An attempt has been made here to identify the products of the Kakiemon kiln.

Perhaps because we admire the Kakiemon wares so greatly, we tend to pay less attention to the other *ko-Imari* wares. Little attempt has been made to classify these, save in date, beyond the obvious criterion of quality. While most kilns must have produced a range of qualities, which is evident from collections of potsherds, some may have specialised in, say, the group of *ko-Imari* wares with no underglaze blue and an especially soft palette (eg No. 224).

Now that much of the porcelain formerly attributed to the Kutani kilns of Kaga has been shown to have been made at Arita (the 1978 find of the Cho-kichi-dani kiln site in Arita is of particular importance) the problem is greater, not less. How then to subdivide the *ko-Imari*? The group may be divided into two: the *ko-Kutani* style wares and the other *ko-Imari* style wares. The latter group is then further divided into groups based on palette and style of painting; these include the two 'no-underglaze-blue' styles, the 'soft-coloured' group (Nos 220–225) and the 'red and gold' group (Nos 218, 219). These wares contrast strongly, both in style and quality, with some of the other groups, not all of which are represented in this collection. Most of the groups with underglaze blue and overglaze enamels could be related to the 'underglaze-blue-only' wares.

The particular interest of this collection is the range of Kakiemon style enamelled wares. The system of classification here is based both on origin and on date. Clearly it is not definitive; although we have progressed somewhat, we still lack, as we did when Gerald Reitlinger formed this great collection, the necessary data.

O. R. Impey

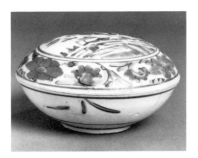

150　Box with cover
Round box with fitting domed cover. Decorated in overglaze blue, red, green and black enamels: on the cover, a landscape in a central medallion with a border of flowers and leaves; outside the bowl, sketchy leaf clusters; inside plain. Gritty foot rim and roughly glazed base.
H: 6cm D: 11.8cm Ft.D: 5.1cm
Early enamelled ware, *c.* 1660
1978.654

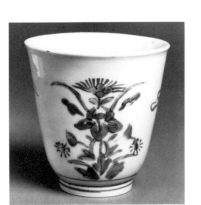

151　Cup
Cup with tall, slightly flaring sides. Decorated in overglaze blue, red, green and black enamels, with a formal vertical flower spray on either side, and sketchy scroll motifs between. Inside plain.
H: 8cm D: 8.2cm Ft.D: 4.3cm
Early enamelled ware, *c.* 1660
1978.652

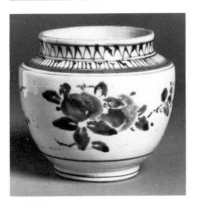

152　Jar
Small jar with flat shoulder and wide neck, the rim unglazed to take a cover. Decorated with sprays of pomegranate and peony in overglaze blue, red and green enamels over the body. Bands of decoration in underglaze blue encircle neck and shoulders.
H: 9.3cm D: 10.5cm Ft.D: 5.6cm
Early enamelled ware, *c.* 1660
1978.653

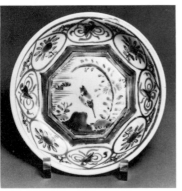

153　Dish
Saucer dish with slightly everted rim. Decorated in overglaze blue, red, green and black enamels, with a bird on a rock in a central medallion, bordered by cartouches containing fan and flower motifs. Outside, three encircling lines in red.
H: 3.3cm D: 13.6cm Ft.D: 7cm
Early enamelled ware, 1660–1670
1978.657

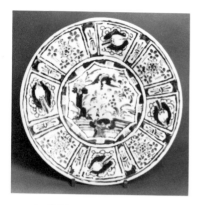

154 Dish

Dish with wide everted rim, decorated in overglaze blue, red, green, yellow and black enamels, with designs derived from Chinese *kraakporselein*: geese by a pond in a central octagonal medallion, bordered by panels containing flowers and emblems. Outside, three sprays of flowers and leaves. The base with five spur marks, chatter marks, and a seal mark in red.
H: 7.3cm D: 32.5cm Ft.D: 13.2cm
Early enamelled ware, 1660–1670
1978.680

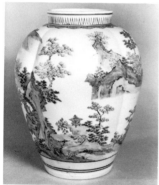

155 Jar

Large jar moulded in four lobes, with a short neck, the rim unglazed to take a cover. Decorated in overglaze blue, red, green, yellow, aubergine and black enamels, with a continuous landscape of pavilions and temples among trees, rocks and mountains. (Colour plate III)
H: 35.2cm D: 29cm Ft.D: 15cm
Early enamelled ware, late 17th century
1978.687

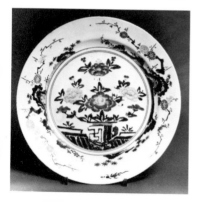

156 Dish

Dish with wide flat rim. Decorated in overglaze blue, red, dark green, yellow and black enamels, with a design derived from Chinese *kraakporselein* of peonies in a vase on a terrace, and on the rim, two spreading prunus trees growing among rocks. Outside plain.
H: 5.5cm D: 32.8cm Ft.D: 16cm
Early enamelled ware, 1670–1680
1978.682

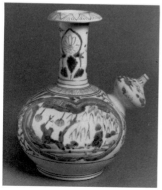

157 Kendi

Kendi with tall neck and turned-back rim. Decorated in overglaze enamels, strong blue and yellow predominating, with a lobed panel on either side of the body containing a sage in a landscape; between the panels, a spreading peacock and prunus blossom; a stylised flower motif on the neck.
H: 21.2cm D: 15cm Ft.D: 9.2cm
Early enamelled ware, 1660–1680
1978.643

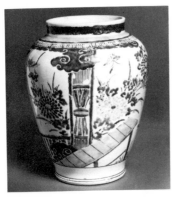

158 Jar
High-shouldered jar with wide neck, the rim unglazed to take a cover. Decorated in overglaze enamels, strong blue and yellow predominating, with flowers in a terraced garden with two verandahs, a curtained pillar, a fence and a trellis.
H: 21.4cm D: 17.3cm Ft.D: 10.1cm
Early enamelled ware, 1660–1680
1978.645

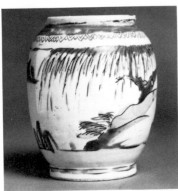

159 Jar
Small ovoid jar with wide mouth, the rim unglazed to take a cover. Decorated in overglaze enamels, strong blue and yellow predominating, with a continuous landscape of a willow tree, junks and drying nets.
H: 10cm D: 8.3cm Ft.D: 5.5cm
Early enamelled ware, 1660–1680
1978.647

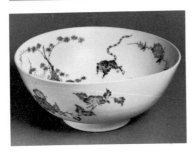

160 Bowl
Large bowl decorated in overglaze enamels in the Kakiemon palette: inside, a central medallion of a dragon chasing a fiery pearl, and on the sides two facing groups of banded hedge, rocks and flowering branches, a tiger between. Outside, two spreading peony sprays. Deeply recessed base with one spur mark.
H: 13.3cm D: 32.5cm Ft.D: 14.5cm
Early Kakiemon style, *c.* 1680
1978.583

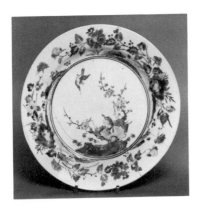

161 Dish
Large dish with wide everted rim, decorated in overglaze enamels in the Kakiemon palette: in the centre, a bird perching on a rock with a prunus tree, another bird flying overhead; on the rim, peonies growing from rocks. Outside plain. Four spur marks to the base.
H: 4.7cm D: 30cm Ft.D: 15cm
Early Kakiemon style, *c.* 1680
1978.681

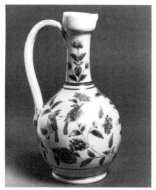

162 Ewer

Ewer with galleried spouted rim and tall handle, pierced at the top for a mount. Decorated in overglaze enamels in the Kakiemon palette, with two pairs of birds among flowers; vertical flower sprays on the neck.
H: 20.4cm D: 10.8cm Ft.D: 6.9cm
Early Kakiemon style, 1670–1680
1978.671

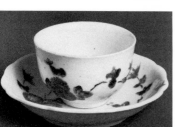

163 Cup and saucer

Small cup with straight rim, and saucer with lobed rim. Decorated in overglaze enamels in the Kakiemon palette, with chrysanthemum sprays inside the saucer and on the outside of the cup. Outside saucer and inside cup, plain.
Cup H: 4.2cm D: 6.5cm Ft.D: 3.2cm
Saucer H: 2.4cm D: 10.9cm Ft.D: 6cm
Early Kakiemon style, c. 1680
1978.592

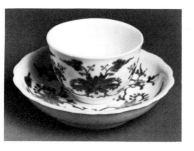

164 Cup and saucer

Small cup with slightly everted rim, and saucer with lobed rim. Decorated in overglaze enamels in the Kakiemon palette, with lotus blossoms linked with formal scrolls and leaves on outside of cup and inside of saucer. Inside cup and outside saucer, plain.
Cup H: 4.2cm D: 6.5cm Ft.D: 2.9cm
Saucer H: 2.5cm D: 10.8cm Ft.D: 6cm
Early Kakiemon style, late 17th century
1978.594

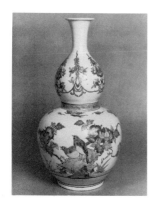

165 Double-gourd vase

Double-gourd vase with flaring rim. Decorated in overglaze enamels in the Kakiemon palette: on the upper bulb, stylised peonies and linked scroll motifs; on the lower bulb, a pair of birds perching on a rock beneath a tree peony, with a smaller plant and butterfly on the other side.
H: 41.8cm D: 22.4cm Ft.D: 12.3cm
Early Kakiemon style, c. 1680
1978.686

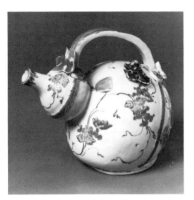

166 Bottle

Bottle or jug in the form of a reclining double-gourd; moulded decoration of vine leaves and a tasselled cord; at one side, a hole with stopper in the form of a vine leaf. Decorated in underglaze blue and overglaze enamels in the Kakiemon palette, with a trailing vine and a tree shrew eating grapes. Flat unglazed base.
H: 16cm L: 19.2cm
Early Kakiemon style, 1680–1700
1978.637

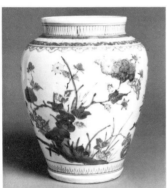

167 Jar

High-shouldered jar with wide neck, rim unglazed to take a cover. Decorated in underglaze blue and overglaze red, yellow, blue, green and black enamels, with a tree peony and a prunus tree growing from rocks, chrysanthemums growing between; decorative bands at rim, shoulder and foot.
H: 21.9cm D: 18.5cm Ft.D: 10.2cm
Kakiemon related style, 1680–1700
1978.667

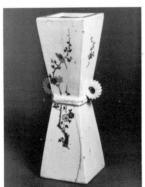

168 Waisted wall vase

Vase shaped like an hourglass of square section, with a moulded band representing a rope round the waist and two notched handles; flat inverted lip; one side pierced at the top for suspension as a wall vase. Decorated in overglaze enamels in the Kakiemon palette, with a prunus tree and birds perching and flying. Flat unglazed base.
H: 20cm W: 6.5cm Ft.W: 6.5cm
Kakiemon related style, late 17th century
1978.673

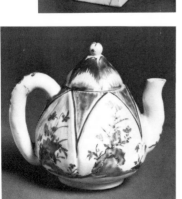

169 Wine pot with cover

Small wine pot with cover, moulded and incised in the form of a lotus bud. Decorated in overglaze enamels in the Kakiemon palette, the 'petals' of the body outlined and decorated with flowering plants growing from rocks; flower and scroll motifs on handle and spout.
H: 10cm D: 8.2cm Ft.D: 4.9cm
Kakiemon related style, c. 1680
1978.639

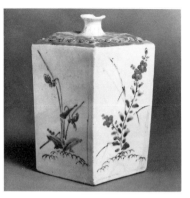

170 Bottle

Bottle of square section with small flaring neck. Decorated in overglaze enamels in the Kakiemon palette, with a flowering plant on each side of the body, and decorative bands on neck and shoulder. Flat unglazed base.
H: 14.5cm W: 8.5cm Ft.W: 7.5cm
Kakiemon related style, *c.* 1680
1978.668

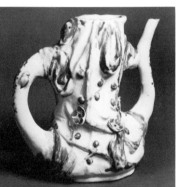

171 Ewer

Ewer modelled in the form of an old prunus tree trunk, with flowering branches; thick hollow handle and curving spout. Cover missing. Decorated in overglaze enamels in the Kakiemon palette with no yellow: moulded flowers painted red and blue; flower scrolls on handle and spout. Flat unglazed base.
H: 16.5cm D: 11.6cm Ft.D: 8.5cm
Kakiemon related style, 1670–1680
1978.644

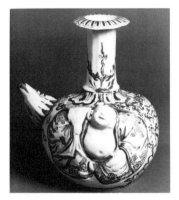

172 Kendi

Kendi with tall faceted neck, everted rim with petalled lip; sides modelled to represent the figure of Hotei on each side; squared spout. Decorated in overglaze enamels in the Kakiemon palette with no yellow, the lines of the moulding picked out, the ground between with scroll work, fan shapes and cash pattern.
H: 19.7cm D: 14.8cm Ft.D: 9cm
Kakiemon related style, 1660–1680
1978.641

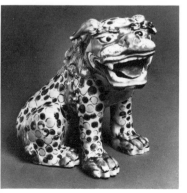

173 Figure

Figure of a *shishi* with open jaws, head turned sideways. Decorated over-all in overglaze enamels in a variation of the Kakiemon palette, with blue and yellow spots, yellow stomach, blue mane and tail, and red tongue. Tail missing.
H: 12.8cm
Kakiemon related style, late 17th century
1978.662

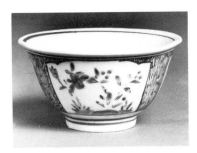

174 Cup
Small cup with wide flaring rim. Decorated in overglaze enamels in the Kakiemon palette with no yellow: inside, a single flower in a double red circle; outside, three panels, reserved on a red basketwork ground, contain peony plants growing from rocks.
H: 3.9cm D: 7.5cm Ft.D: 3.2cm
Kakiemon related style, c. 1680
1978.601

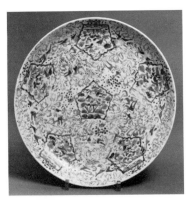

175 Dish
Large saucer dish decorated in overglaze enamels, yellow, green and blue predominating, with touches of red and black: inside, a dense design of flying birds among leaves and flowers, with six-lobed pentagons each containing a bird perched in a tree; outside, three horizontal peony sprays in red and green. Three spur marks to the base.
H: 3.7cm D: 25cm Ft.D: 15.9cm
Kakiemon related style, 1680–1700
1978.649

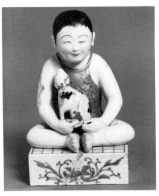

176 Group
Group of a boy with a dog, sitting on a square *shogi* table. Decorated in overglaze enamels in the Kakiemon palette, with the table marked out in underglaze blue. The boy's bib is red, with a scroll pattern in green, blue and gold; the sides of the base with formal flower scrolls.
H: 18.4cm
Kakiemon related style, 1680–1700
1978.670

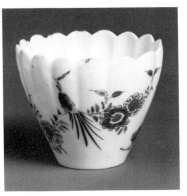

177 Cup
Cup with fluted sides and scalloped rim. Decorated in overglaze enamels in the Kakiemon palette with gold. Outside, with chrysanthemums and two pheasants. Inside plain. Recessed glazed base, with a Johanneum inventory number, $N=114$, over a rectangle.
H: 5.5cm D: 7cm Ft.D: 3.4cm
Kakiemon related style, c. 1700
1978.606

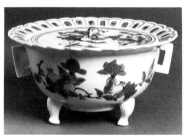

178 Koro with cover

Koro with flat cover, a central knob moulded in the form of a peach and leaf, two square handles and three moulded feet. Decorated in overglaze enamels in a variation of the Kakiemon palette, with sprays of pomegranate on cover and sides, and lappets on the scalloped rim. Inside plain.
H: 16.2cm D: 8.2cm
Kakiemon related style, 1680–1700
1978.669

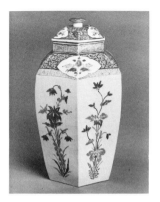

179 Jar with cover

Jar with cover, of hexagonal section (the so-called 'Hampton Court' shape). Decorated in overglaze enamels in a variation of the Kakiemon palette including brown: a tall flowering plant on each face of the body; on shoulder and cover, cartouches containing formal flower sprays, reserved against a ground of red with green scroll work. Flat unglazed base.
H: 31cm D: 19cm Ft.D: 13.3cm
Kakiemon related style, 1680–1690
1978.688

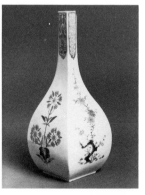

180 Vase

Bottle vase of square section with tapering neck. Decorated in overglaze enamels in the Kakiemon palette with gold: stylized sprays of prunus and daisy are repeated on opposite sides of the body; on the neck, panels of scroll work and formal flower design in red and gold. Flat unglazed base.
H: 22.2cm W: 8.2cm Ft.W: 5.2cm
Kakiemon related style, late 17th century
1978.538

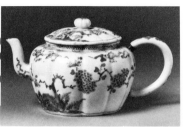

181 Wine pot with cover

Small wine pot with cover, of oval section, moulded in ten lobes. Knob and handle have marks where a metal mount was fitted. Decorated in overglaze enamels in the Kakiemon palette, with prunus growing from rocks; lappet band and cloud scrolls on shoulder; green scrolls on handle and spout.
H: 8.2cm D: 9.6cm Ft.D: 7.2cm
Kakiemon, 1680–1700
1978.659

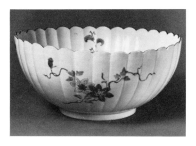

182　Bowl

Large bowl with fluted sides and scalloped brown-edged rim. Decorated in overglaze enamels in the Kakiemon palette: inside, three peony sprays in red and gold with green curling leaves; outside, three sprays of clematis, yellow being used instead of gold. One spur mark to the base.
H: 11cm D: 25cm Ft.D: 11.4cm
Kakiemon, *c.* 1700
1978.539

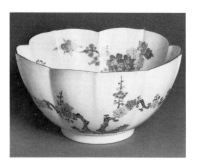

183　Bowl

Bowl with sides moulded in five lobes, and petalled brown-edged rim. Decorated in overglaze enamels in the Kakiemon palette: inside, two spreading peony trees growing from rocks; outside, a prunus tree and a bamboo.
H: 9.4cm D: 18.8cm Ft. D:8.2cm
Kakiemon, early 18th century
1978.528

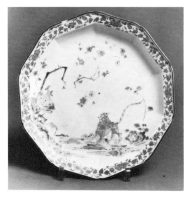

184　Dish

Decagonal saucer dish with panelled sides, everted rim and flanged lobed lip with brown edge. Decorated in overglaze enamels in the Kakiemon palette, with a tiger by a stream beneath a prunus tree; peony wreath on rim. Outside plain. Circular foot ring. Three spur marks to the base.
H: 3.2cm D: 19.4cm Ft.D: 12cm
Kakiemon, *c.* 1700
1978.572

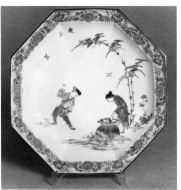

185　Dish

Octagonal saucer dish with panelled sides, everted rim and flanged lip with brown edge. Decorated in overglaze enamels in the Kakiemon palette with no yellow, with a scene illustrating the 'Hob in the well' story; elaborate floral border on rim. Outside plain. Circular foot ring. Three spur marks to the base.
H: 3.3cm D: 20.4cm Ft.D: 11.2cm
Kakiemon, *c.* 1700
1978.573

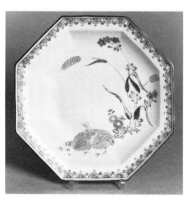

186 Dish

Octagonal saucer dish with panelled sides, everted rim
and flanged lip with brown edge. Decorated in overglaze
enamels in the Kakiemon palette, with two quails beneath
flowers and millet stalks; floral lappet border on rim.
Circular foot ring. Outside plain. Three spur marks to
the base.
H: 4.9cm D: 25.6cm Ft.D: 13.5cm
Kakiemon, *c.* 1700
1978.574

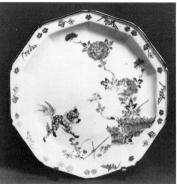

187 Dish

Decagonal saucer dish with panelled sides, everted rim
and flanged lobed lip with brown edge. Decorated in
overglaze enamels in the Kakiemon palette, with a *shishi*
in blue with yellow spots and red mane and tail, beside a
tall peony growing from a trellis with banded hedges.
Border of 'thunder and lightning' fret pattern and florets
on the rim. Outside plain. Circular foot ring. Four spur
marks to the base.
H: 3.2cm D: 19.3cm Ft.D: 12cm
Kakiemon, *c.* 1700
1978.560

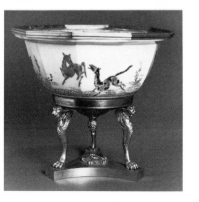

188 Bowl with gilt-bronze mounts

Decagonal bowl with panelled sides and everted rim with
flanged brown-edged lip. Decorated in overglaze enamels
in the Kakiemon palette: inside, a central rosette with the
panelled sides outlined, on the sides, a flowering plant
and a phoenix medallion, each repeated opposite; outside,
two pairs of horses with clumps of flowering plants.
Decagonal foot. Gilt-bronze mounts: French, Empire style.
H. 22.2cm D: 24.6cm
Kakiemon, early 18th century
1978.664b

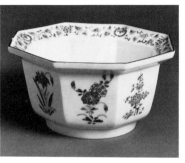

189 Bowl

Octagonal bowl with panelled sides and everted rim with
flanged, brown-edged lip. Decorated in overglaze enamels
in the Kakiemon palette, with a single prunus blossom in
the centre, a floral border on the rim, on each outer face a
single flowering plant: iris, chrysanthemum, prunus and
peony each repeated opposite. Circular foot ring.
H: 7.4cm D: 14.8cm Ft.D: 7.7cm
Kakiemon, *c.* 1700
1978.566

190 Bowl
Octagonal bowl with panelled sides and everted rim with flanged brown-edged lip. Decorated in overglaze enamels in the Kakiemon palette: a medallion of two fighting game cocks in the centre; peony wreath on rim; outside, two prunus trees and bamboo growing from rocks. Circular foot ring.
H: 9.8cm D: 19.4cm Ft.D: 8.3cm
Kakiemon, c. 1700
1978.557

191 Cup
Octagonal cup with panelled sides and wide everted rim. Decorated in overglaze enamels in the Kakiemon palette, red, blue and turquoise predominating, with a meandering spray of chrysanthemum and a single flower outside; three peony scrolls on the rim; inside plain. Circular foot ring.
H: 8cm D: 11.8cm Ft.D: 5.4cm
Kakiemon, c. 1700
1978.549a

192 Dish
Small saucer dish of squared shape, with rounded corners and curving sides; the rim with a deep triple scallop in each side. Decorated in overglaze enamels in the Kakiemon palette, with a coiled dragon in the centre, and three 'lightning flashes' on the sides. Outside plain. Circular foot ring.
H: 3cm D: 9.6cm Ft.D: 5.2cm
Kakiemon, c. 1700
1978.588

193 Cup
Small cup with panelled sides and flaring six-pointed rim. Decorated in overglaze enamels in the Kakiemon palette: inside, a single rosette; outside, a spray of chrysanthemum in grass. Circular foot ring with rather gritty rim.
H: 4.5cm D: 7.8cm Ft.D: 2.9cm
Kakiemon, c. 1700
1978.600

194 Dish

Saucer dish decorated in underglaze blue and overglaze enamels in the Kakiemon palette, with a lakeside landscape in the centre, mainly in underglaze blue, and a border of peony, prunus and pomegranate growing from rocks. Outside plain. Four spur marks to the base.
H: 3.1cm D: 19.9cm Ft.D: 11.5cm
Kakiemon derivative ware, early 18th century
1978.634

195 Dish

Saucer dish with everted, eight-lobed rim. Decorated in underglaze blue and overglaze enamels in the Kakiemon palette, with two cranes standing in water; border of peony and prunus growing from rocks, birds flying above; outside, a leafy meander in underglaze blue. Circular foot ring. On the base, three spur marks and a four-character corrupt Chinese mark, *xuan Ming nien ji*, in a double circle.
H: 2.7cm D: 19.7cm Ft.D: 12.6cm
Kakiemon derivative ware, early 18th century
1978.629

196 Ewer with copper-gilt mounts

Ewer with narrow neck swelling at the rim, four vertical panels on the body moulded with a wave pattern in shallow relief. Decorated in underglaze blue and overglaze enamels: the four panels on the body contain a scene with a Geisha and curtain, repeated on each side; panels containing flower and leaf motif on the shoulder. Base almost flat, glazed only in the centre. Stopper and chain in copper gilt.
H: 21.2cm D: 9.5cm Ft.D: 6.7cm
Kakiemon derivative ware, late 17th century
1978.638

197 Vase

Tall bucket-shaped vase of square section with squared yoke handle. Decorated in overglaze enamels in the Kakiemon palette, with a bird perching on one branch of a spreading camellia tree and another in flight. Scroll pattern on the handle. Flat unglazed base.
H: 23.2cm W: 10.3cm Ft.W: 7.4cm
Kakiemon derivative ware, late 17th century
1978.672

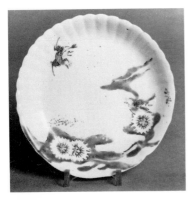

198 Dish

Saucer dish with asymmetrically moulded sides: one half with chrysanthemum-petal fluting, the other with broad lobed petals. Decorated in overglaze enamels, with two green birds, yellow and white flowers reserved against the blue of a stream, and touches of red. Outside plain.
H: 3.2cm D: 14.3cm Ft.D: 8.6cm
Kakiemon derivative ware, 1660–1680
1978.675

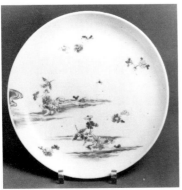

199 Dish

Saucer dish decorated in overglaze enamels in the Kakiemon palette, with flower sprays floating on swirling water, and scattered on the white ground. Outside, two simple leaf sprays, and three encircling lines in red. Low foot ring with some grit adhering. Three spur marks to the base.
H: 3.3cm D: 20.8cm Ft.D: 14.3cm
Kakiemon derivative ware, late 17th century
1978.679

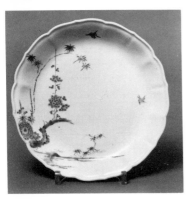

200 Dish

Saucer dish with fluted sides and flanged rim lobed in eight petals. Decorated in overglaze enamels in the Kakiemon palette, with prunus, bamboo and chrysanthemum growing by a stream, and two birds in flight. Outside plain. Circular foot ring. Two spur marks to the base.
H: 3.1cm D: 19cm Ft.D: 12.1cm
Kakiemon derivative ware, early 18th century
1978.676

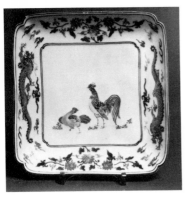

201 Dish

Square saucer dish with fluted corners and lobed brown-edged rim. Decorated in underglaze blue and overglaze enamels in the Kakiemon palette, with a cock and hen in the centre, and a border of two facing dragons, formal lotus sprays and cloud scrolls. Outside, four scroll designs in underglaze blue. Circular foot ring. On the base, five spur marks and a square *fuku* mark in a blue circle.
H: 3.7cm D: 25.8cm Ft.D: 14.6cm
Kakiemon derivative ware, early 18th century
1978.624

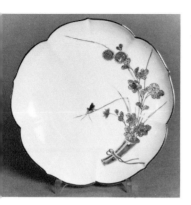

202 **Dish**
Five-lobed saucer dish with fluted sides and petalled brown-edged rim. Decorated in overglaze enamels in a variation of the Kakiemon palette with aubergine but no yellow, with a sheaf of chrysanthemums and grass blades in a scroll of paper tied with a ribbon. A grasshopper perching on one grass blade. Outside plain. Circular foot ring. Four spur marks to the base.
H: 3.4cm D: 19cm Ft.D: 11.5cm
Kakiemon derivative ware, early 18th century
1978.564

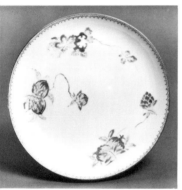

203 **Dish**
Saucer dish with brown-edged rim, decorated in overglaze enamels in the Kakiemon palette, yellow and red predominating, with three fruit sprays: pomegranate, persimmon and finger citron. At the rim, a band of triangle ornament in red. Outside plain. Three spur marks to the base.
H: 3.2cm D: 18cm Ft.D: 12cm
Kakiemon derivative ware, mid 18th century
1978.558

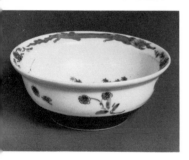

204 **Bowl**
Bowl with everted concave rim. Decorated in overglaze enamels in the Kakiemon palette: in the centre, a leaping tiger beneath bamboo and prunus, on the rim, two dragons chasing fiery pearls; outside, peony sprays and scattered blossoms, the lower half of the bowl covered with a brown glaze.
H: 5.4cm D: 13.2cm Ft.D: 6.7cm
Kakiemon derivative ware, c. 1700
1978.612

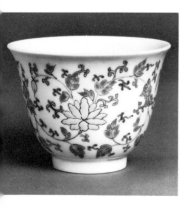

205 **Cup**
Small cup with everted rim, decorated in overglaze enamels in a rather pale version of the Kakiemon palette, blue and yellow predominating, with a lotus scroll covering the outside. Inside plain.
H: 5.4cm D: 7.3cm Ft.D: 3.3cm
Kakiemon derivative ware, possibly late 18th century
1978.604

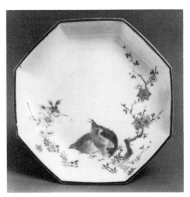

206 Dish

Octagonal saucer dish, the rim with a flat brown edge. Decorated in overglaze enamels in the Kakiemon palette, with two quails beneath a prunus tree among flowering plants. Outside plain. Circular foot ring.
H: 3cm D: 11.8cm Ft.D: 6.8cm
Kakiemon derivative ware, early–mid 18th century
1978.621

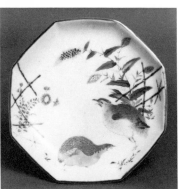

207 Dish

Octagonal saucer dish with brown-edged rim. Decorated in underglaze blue and overglaze enamels in the Kakiemon palette with gold, with two quails beneath millet stalks growing on a trellis. Outside, three conventional scrolls. Circular foot ring. On the base, one spur mark and a square *fuku* mark in a blue circle.
H: 3.2cm D: 15.3cm Ft.D: 9.8cm
Kakiemon derivative ware, mid–late 18th century
1978.524

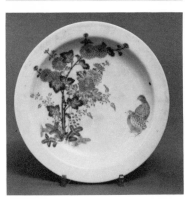

208 Dish

Saucer dish with flat everted rim. Decorated in underglaze blue and overglaze enamels in a version of the Kakiemon palette with no yellow, with two quails and a tall clump of chrysanthemums. On each outer side, in underglaze blue, a bird perches on a flowering branch growing from rocks. On the base, five spur marks and a cursive *fuku* mark in a double square, within a circle.
H: 3.4cm D: 21.6cm Ft.D: 12.8cm
Kakiemon derivative ware, c. 1800
1978.512

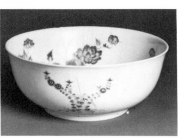

209 Bowl

Bowl with slightly flaring rim, decorated in overglaze enamels in the Kakiemon palette: on facing inner sides, two spreading peony plants growing from rocks; outside, three chrysanthemum plants growing in grass. Four spur marks to the base.
H: 7.8cm D: 20.2cm Ft.D: 11cm
Kakiemon derivative ware, late 18th century
1978.543

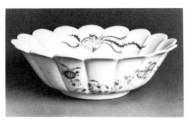

210 Bowl

Bowl with flaring fluted sides and scalloped rim.
Decorated in overglaze enamels in the Kakiemon palette;
inside, a pomegranate spray in the centre, and on opposite
sides a spreading phoenix and a spray of berries; outside,
two groups of flowering plants growing from rocks.
H: 7cm D: 21.5cm Ft.D: 9.2cm
Kakiemon derivative ware, 19th–20th century
1978.516

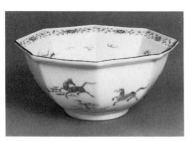

211 Bowl

Octagonal bowl with panelled sides and everted rim with
flanged brown-edged lip. Inside, each face moulded in
shallow relief with a single flowering plant. Decorated in
overglaze enamels in the Kakiemon palette, with a flying
phoenix on either side inside, a peony wreath on the rim;
the outside, with four horses running and grazing on grass.
Circular foot ring.
H: 8.1cm D: 18.9cm Ft.D: 7.5cm
Kakiemon derivative ware, 19th century
1978.520

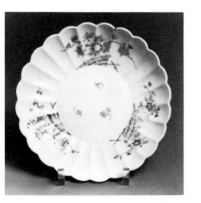

212 Dish

Saucer dish with fluted sides and scalloped rim. Decorated
in overglaze enamels similar to the Kakiemon palette with
rather pale blue: three blossoms in the centre, and three
flowering trees growing from banded hedges on the sides.
Outside, three groups of blue and green leaves.
H: 3.5cm D: 16.5cm Ft.D: 9cm
Kakiemon derivative ware, probably Kaga, 20th century
1978.584

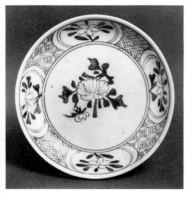

213 Dish

Small saucer dish, decorated in overglaze red, green,
yellow and black enamels, with a cluster of flowers and
leaves in the centre and four more in oval reserves against
a diaper border on the sides. Outside plain. The base with
a single spur mark and a square *fuku* mark in red.
H: 2.1cm D: 13.8cm Ft.D: 8cm
ko-Imari, mid–late 17th century
1978.413

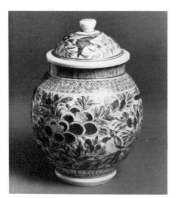

214 Jar with cover
Small round-bodied jar with domed knobbed cover. Decorated in overglaze enamels, red predominating, with a dense design of birds among flowers and foliage, and bands of formal ornament, with encircling lines of underglaze blue. Small ridged foot.
H: 14.3cm D: 10.2cm Ft.D: 5cm
ko-Imari, 1670–1680
1978.534

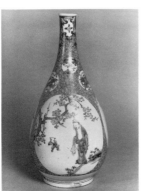

215 Vase
Pear-shaped bottle vase with rounded lip. Decorated in overglaze red, green, yellow and aubergine: three large lobed panels each with a sage in a landscape, and six roundels above with flowers and emblems, in reserve against a ground of red scroll pattern. Cartouche design at rim. Straight foot ring; recessed, slightly convex, base.
H: 39cm D: 20.1cm Ft.D: 13cm
ko-Imari, 1660–1680
1978.689

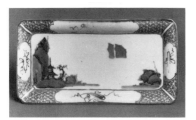

216 Dish
Rectangular saucer dish with everted brown-edged rim slightly lobed at the corners. Decorated with a lake scene in underglaze blue in the central panel, and on the sides, in overglaze red and brown enamels, ribboned picture scrolls in four oval reserves against a ground of basketwork diaper. Outside plain. High sloping foot.
H: 2.5cm W: 18.6cm Ft.W: 14cm
ko-Imari, late 17th century
1978.480

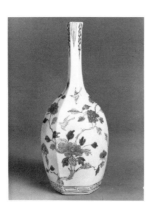

217 Vase
Bottle vase of hexagonal section with tall narrow neck. Decorated in overglaze red, blue, aubergine, yellow and black enamels with some gold, with birds flying among peony and prunus branches. Flat unglazed base, with an inventory number in burnt ink.
H: 23.8cm D: 10cm Ft.D: 7.2cm
ko-Imari, late 17th century
1978.461

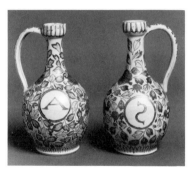

218 Pair of Ewers

A pair of ewers, each with galleried spouted rim and tall handle. Decorated in overglaze red enamel and gold, with an over-all design of scrolling peony sprays, and a circular medallion on either side, containing respectively an 'A' and a reversed 'S'.
Each ewer H: 19.5cm D: 10.4cm Ft.D: 6.5cm
ko-Imari, c. 1700
1978.423 & 1978.424

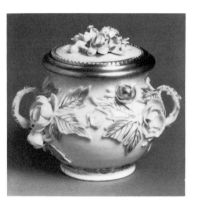

219 Koro with cover and gilt-bronze mounts

Koro with peony clusters moulded in high relief, their stalks forming two handles; flat cover pierced with two holes. Sparsely decorated in overglaze red enamel and gold. Mounted in gilt-bronze to make an inkwell, the base having a central hole to take a screw to an inkstand: French, eighteenth century.
H: 9cm D: 10cm Ft.D: 4.7cm
ko-Imari, c. 1700
1978.422

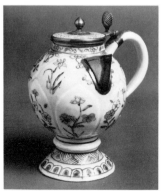

220 Mustard pot with silver mounts

Mustard pot with flat pierced cover and loop handle, the body moulded with tiered petals in shallow relief. Decorated in overglaze red enamel and gold, with some green and aubergine: the petals outlined in gold, with flower sprays and various formal bands. Tall spreading hollow foot. Silver mounts: Dutch, eighteenth century.
H: 11.4cm D: 7.5cm Ft.D: 5.7cm
ko-Imari, c. 1680
1978.419

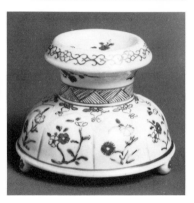

221 Salt

Salt in the form of a hollow inverted goblet, on three ball feet. Moulded and decorated to match the mustard pot, No. 220.
H: 6.4cm D: 9cm
ko-Imari, c. 1680
1978.427

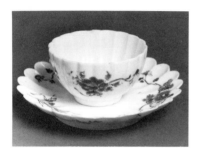

222 Cup and saucer

Small cup with fluted sides, and fluted saucer with scalloped rim. Decorated in overglaze red, green, yellow and black enamels with some gold: clusters of pomegranate in the centre of each piece; flower sprays on outside of cup and inside of saucer; outside of saucer and base of each piece, a sketchy floral motif in red and green.
Cup H: 4cm D: 7.6cm Ft.D: 3.7cm
Saucer H: 2.3cm D: 12.7cm Ft.D: 7.4cm
ko-Imari, c. 1700
1978.608

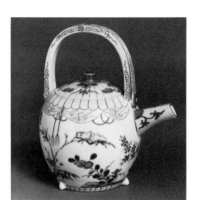

223 Wine pot with cover

Wine pot with knobbed cover and overhead handle. Decorated in overglaze red, turquoise, green, yellow, aubergine and black enamels with gold. On the body, a flowering tree and bamboo growing among rocks and flowers, a rolled-up blind and a striped bench; tasselled curtains and a lappet border continue from radiating lines on the cover. Three small feet project level with the base.
H: 16.5cm D: 11cm Ft.D: 7.2cm
ko-Imari, 1700–1720
1978.499

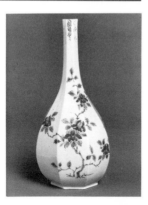

224 Bottle

Bottle vase of octagonal section with tall narrow neck. Decorated in overglaze red, turquoise, green, aubergine and black enamels with gold, with a peony tree and a persimmon tree spreading over the body. Very low foot. Flat unglazed base. (Colour plate IV)
H: 22.3cm D: 11.7cm Ft.D: 7.4cm
ko-Imari, late 17th century
1978.431

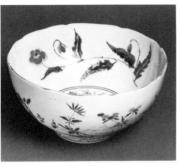

225 Bowl

Bowl with slightly lobed, gilded rim. Decorated in overglaze red, green, turquoise, aubergine, yellow and black enamels with gold: inside, a central medallion containing a design of flowers in a basket; on the sides, a spray of prunus and chrysanthemum, and a poppy; outside, various flowering plants growing from trellises. Straight foot ring.
H: 12cm D: 25cm Ft.D: 11cm
ko-Imari, c. 1720
1978.440

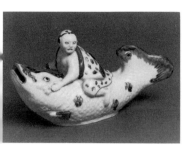

226 Group
Group with Benkei on a swimming carp, the carp moulded with scales. Decorated in underglaze blue and overglaze enamels with gold, the carp marked in blue and gold, the boy's kimono spotted green and aubergine and bordered with red. Flat unglazed base with burnt initial, ⋏.
H: 14cm
ko-Imari, c. 1700
1978.447

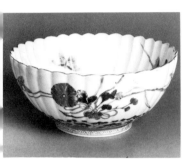

227 Bowl
Bowl with fluted sides and scalloped gilded rim. Decorated with bands of ornament in underglaze blue, and in overglaze red, green, aubergine, turquoise, black and yellow enamels with gold. Inside, a central medallion with a daisy cluster; a spray of chrysanthemums and orchids beginning outside and continuing over the rim and round the inside. Straight foot ring; on the base, in underglaze blue, a square *fuku* mark in a circle.
H: 8.5cm D: 18.7cm Ft.D: 8.8cm
ko-Imari, c. 1720
1978.488

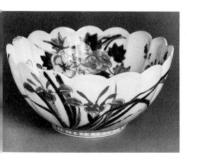

228 Bowl
Bowl with fluted sides and scalloped rim. Decorated in underglaze blue and overglaze red, green, turquoise, yellow and black enamels with gold. Inside, a central medallion with a spray of cherry blossom; on the sides, peony and chrysanthemum, grasses and ivy leaves; outside, an iris, and a peony growing from a banded hedge. Low straight foot ring; the base with a double circle in underglaze blue.
H: 9.8cm D: 20.8cm Ft.D: 9.5cm
ko-Imari, 1700–1720
1978.433

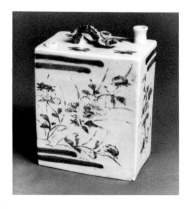

229 Bottle
Bottle of rectangular section with small funnel spout in one corner of the top, rosette bung hole in opposite corner, handle moulded as a fungus. Decorated in underglaze blue and overglaze red, green, aubergine, brown, black and yellow enamels, with peony and chrysanthemum plants spreading round the sides. Flat unglazed base, with canvas imprint.
H: 14.7cm W: 11.2cm
ko-Imari, early 18th century
1978.432

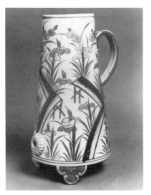

230 Coffee pot

Coffee pot with handle, and low bung hole in moulded rosette opposite; rim unglazed to take a cover, handle pierced for a mount. Decorated in underglaze blue and overglaze red and pink enamels with gold, with irises, reeds and the Yatsuhashi bridge. Flat unglazed base, on three lobed feet.
H: 28.4cm D: 9.2cm Ft.D: 15cm
ko-Imari, early 18th century
1978.446

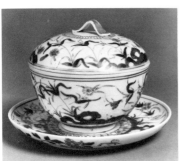

231 Bowl with cover and saucer stand

Bowl, fitting domed cover with flat loop handle, and saucer stand. Decorated in underglaze blue and overglaze red, yellow, green and turquoise enamels with gold, with a main design of daisies growing from rocks. In centre of bowl, a single peony in vase; in centre of saucer, a vase of flowers with three peony sprays on the outside. Four spur marks to base of saucer.
Bowl and cover H: 10.7cm D: 13cm Ft.D: 6cm
Saucer H: 2.5cm D:17.5cm Ft.D: 11.9cm
ko-Imari, early 18th century
1978.484

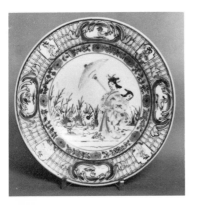

232 Dish

Dish with wide flat everted rim. Decorated in underglaze blue and overglaze red, aubergine, green and black enamels with gold (after a design by Cornelis Pronk executed between 1734 and 1738): in the centre, Geishas with a parasol and strutting birds; border of flower heads on the cavetto; on the rim, panels with birds and Geishas in reserve against a ground of octagon pattern. Low foot ring. Four spur marks to the base.
H: 4cm D: 22.2cm Ft.D: 11.7cm
ko-Imari, after 1735
1978.489

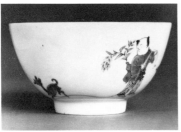

233 Bowl

Bowl decorated in overglaze red, blue, green and black enamels with gold, with a boy carrying a sheaf of corn on his back, and leading a dog which is barking at a pair of flying birds. Inside plain. Straight foot ring.
H: 5.8cm D: 10.7cm Ft.D: 4.7cm
ko-Imari, first half of 18th century
1978.578

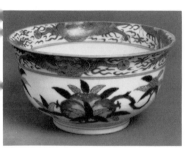

234 Bowl

Bowl with everted gilded rim, decorated in underglaze blue and overglaze red, green, yellow and black enamels. Inside, a peach spray; at rim, inside and outside, a border of dragons and cloud scrolls; outside, sprays of finger citron, peach and pomegranate. Straight foot ring. On the base in underglaze blue, a distorted six-character mark of Jiajing in a circle.
H: 8.7cm D: 16.9cm Ft.D: 7.1cm
ko-Imari, probably late 18th century
1978.505

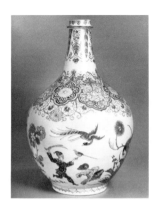

235 Vase

Large bottle vase with flange below the rim. Decorated in Holland, in overglaze enamels in Imari style, with red predominating: European figures, birds among flowering plants, and elaborate ornament at neck and shoulder. Straight foot ring. One spur mark to the base.
H. 48cm D: 32cm Ft.D: 16.3cm
ko-Imari, late 17th century
1978.1804

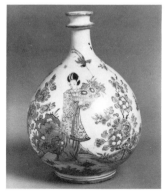

236 Vase

Bottle vase with double-flanged rim. Decorated in Holland, in overglaze enamels in Imari style, with red predominating: three figures standing among flowering trees, birds and butterflies on the wing, one bird perching in a camellia tree. Straight foot ring, roughly formed. Chatter marks to the base.
H: 22.2cm D: 16cm Ft.D: 8.5cm
ko-Imari, late 17th century
1978.1353

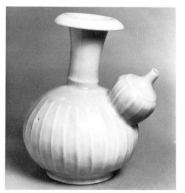

237 Kendi

Kendi with tall neck and turned-back rim, moulded with ribs on body and spout. Decorated over-all with a pale celadon glaze, but for the foot rim which shows a reddish biscuit.
H: 21cm D: 15.8cm Ft.D: 9.3cm
ko-Imari, 17th century
1978.1094

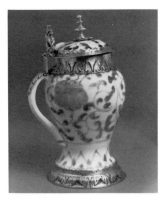

238 Mustard pot with cover and silver-gilt mounts
Mustard pot with handle and slightly domed pierced cover, decorated in underglaze blue with peony scrolls and triangle ornament. Splayed base, wide flat foot rim. Moulded loops for a chain, on lid and handle, have been broken away to make room for the mounts. Silver-gilt mounts: Dutch, seventeenth century.
H: 15cm D: 7.6cm Ft.D: 7.5cm
Arita, 1660–1680
1978.770

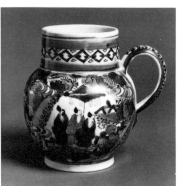

239 Tankard
Tankard with tall cylindrical neck and handle pierced at the top for a metal mount to a cover. Decorated in underglaze blue with figures in a landscape in Chinese Transitional style, and bands of formal ornament. Low, rather gritty, foot ring.
H: 15.5cm D: 13.4cm Ft.D: 8.3cm
Arita, 1660–1680
1978.690

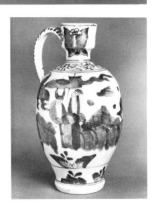

240 Jug
Jug with galleried spouted rim and high loop handle. Decorated in underglaze blue with figures in a landscape in Chinese Transitional style; two butterflies on the neck; *karakusa* scroll and diaper on the shoulder; four clumps of flowers at the foot.
H: 24.2cm D: 13.4cm Ft.D: 7.4cm
Arita, 1660–1680
1978.723

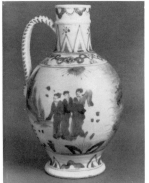

241 Ewer
Ewer with cylindrical neck with intermediate torus ring, and loop handle pierced at the top for a mount to a cover. Decorated in underglaze blue with figures in a landscape in Chinese Transitional style, and bands of formal ornament. Concave base with a flower mark.
H: 25.7cm D: 16cm Ft.D: 9.8cm
Arita, 1660–1680
1978.700

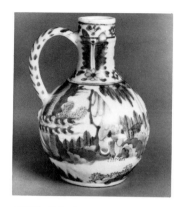

242 Ewer
Ewer with cylindrical neck with intermediate torus ring, and loop handle pierced at the top for a mount to a cover. Decorated in underglaze blue with figures in a landscape in Chinese Transitional style; stylised tulips on neck.
H: 18.5cm D: 13cm Ft.D: 7.6cm
Arita, 1660–1680
1978.768

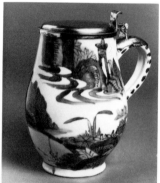

243 Tankard with silver mounts
Tankard with ovoid body and loop handle, decorated in underglaze blue with figures seated in a landscape in Chinese Transitional style. Mounted with a silver cover hinged to the handle: Dutch, *c.* 1680.
H: 16cm D: 11.4cm Ft.D: 7.2cm
Arita, 1660–1680
1978.763

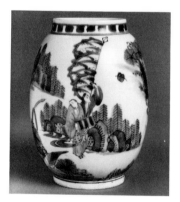

244 Jar
Ovoid jar with rim unglazed to take a cover. Decorated in underglaze blue with two figures carrying a banner, and two seated, in a landscape in Chinese Transitional style. The glazed base has a small fissure.
H: 17.4cm D: 13.2cm Ft.D: 7.4cm
Arita, 1660–1690
1978.760

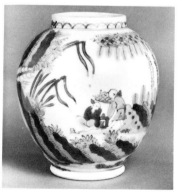

245 Jar
Ovoid jar with short neck left unglazed inside to take a cover. Decorated in underglaze blue with two pairs of figures: a scholar and attendant, and two scholars seated together, in a landscape in Chinese Transitional style.
H: 16.8cm D: 15.5cm Ft.D: 8.1cm
Arita, 1660–1680
1978.701

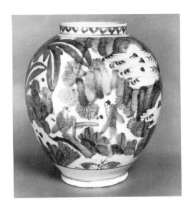

246 Jar
Large ovoid jar with short neck, decorated in underglaze blue with figures in a landscape in Chinese Transitional style, with rocks, banana palm and swirling clouds.
H: 28.5cm D: 28.2cm Ft.D: 14cm
Arita, 1660–1680
1978.725

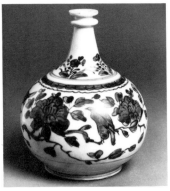

247 Vase
Bottle vase with double-flanged rim. Decorated in underglaze blue with birds, two perching, one flying, among branches of pomegranate and peony. Four flower sprays on neck. Slightly gritty foot rim.
H: 17cm D: 14cm Ft.D: 8.2cm
Arita, 1660–1690
1978.691

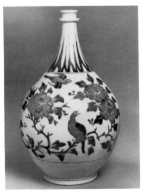

248 Vase
Large bottle vase with double-flanged rim. Decorated in underglaze blue with birds flying and perching among peony branches; ascending triangle ornament on neck.
H: 40cm D: 26.3cm Ft.D: 14.2cm
Arita, 1660–1690
1978.726

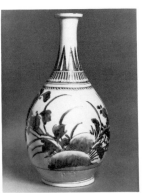

249 Vase
Large bottle vase with upturned rim; chatter marks around the lower part of the body. Decorated in underglaze blue with peony and chrysanthemum sprays growing from rocks, bands of lappets and stiff leaf ornament on shoulder and neck. Base recessed and slightly convex.
H: 44.5cm D: 24.5cm Ft.D: 14.8cm
Arita, 1660–1680
1978.727

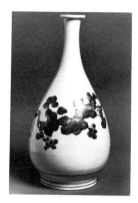

250 Vase
Large bottle vase of slender pear shape, with slightly flaring rim and flanged lip. Decorated in underglaze blue with a single trailing vine round the body. Small hole in base.
H: 38.5cm D: 19.2cm Ft.D: 13.4cm
Arita, 1660–1690
1978.769

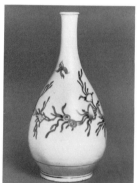

251 Vase
Bottle vase of slender pear shape, with slightly flaring rounded rim. Decorated in underglaze blue with a continuous trail round the body of seaweed and shells.
H: 28cm D: 14cm Ft.D: 9.3cm
Arita, 1670–1690
1978.734

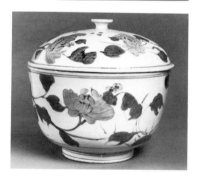

252 Bowl with cover
Large bowl with fitting domed cover with flat-topped knob. Coarsely decorated in underglaze blue with a bold peony spray on both bowl and cover. Straight foot ring. The base very deeply recessed.
H: 22.7cm D: 23.9cm Ft.D: 11.8cm
Arita, late 17th century
1978.702

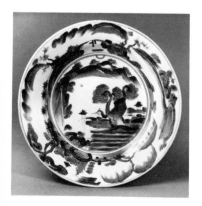

253 Dish
Large dish with wide flat rim. Decorated in underglaze blue with a lakeside scene in the centre, and on the rim, a wide border of islands, bridges, temples and willows in a continuous landscape. Outside, two perfunctory floral scrolls. Low foot ring; on the base, five spur marks and a single wide blue circle.
H: 5.9cm D: 36.2cm Ft.D: 19.3cm
Arita, c. 1680
1978.747

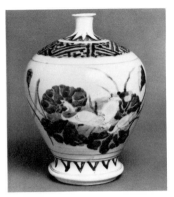

254 Vase
Bottle vase with very wide shoulder and small neck with everted rim. Decorated in underglaze blue with cranes reserved in white against water plants on both sides of the body; diaper pattern on the shoulder, and triangle bands at neck and foot. Splayed foot stepped back to a straight foot ring.
H: 25.7cm D: 19.7cm Ft.D: 10.5cm
Arita, probably late 17th century
1978.729

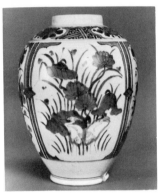

255 Jar
Large ovoid jar with short neck left unglazed for an externally fitting cover. Decorated in underglaze blue with four vertical panels framing alternately lotuses with herons in reserve against a blue wash, and camellias growing from rocks; on the shoulder, peony flowers in four lobed panels against a ground of key pattern. Notch carved out at one side of foot.
H: 33cm D: 26cm Ft.D: 13cm
Arita, c. 1680
1978.730

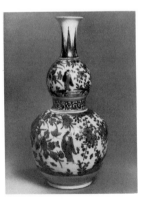

256 Double-gourd vase
Large double-gourd vase with tall flaring neck. Decorated in underglaze blue with the same design on upper and lower bulbs, of figures by a river among peonies and prunus blossom.
H: 43.5cm D: 20cm Ft.D: 12.5cm
Arita, 1670–1690
1978.715

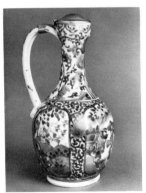

257 Ewer with pewter mounts
Tall-necked ewer with galleried spouted rim and loop handle. Decorated in underglaze blue with three landscape panels against a ground of *karakusa* scroll. On the neck, a vertical flower design amid scroll pattern. Pewter mounts: Dutch, eighteenth century.
H: 23cm D: 12.2cm Ft.D: 7.8cm
Arita, 1680–1700
1978.694

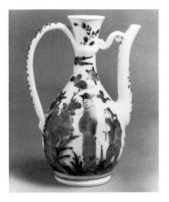

258 Ewer
Small ewer with flaring rim, loop handle and spout, joined with a moulded strut to a torus ring on the neck.
Decorated in underglaze blue with a scholar and attendant beside a peony plant on one side, and a bird with pomegranate sprays on the other. Some grit on foot rim.
H: 17.8cm D: 9.3cm Ft.D: 6.2cm
Arita, 1670–1700
1978.737

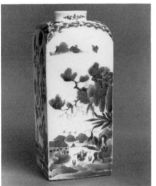

259 Jar
Tall jar of square section, the short slightly flaring neck with an internal step to take a cover. Decorated in underglaze blue with European-derived motifs: landscape scenes and stylised flowering plants on alternate sides of the body; on the shoulder, a border of ornament including a mask, fruit swags, wreaths and a crowned heraldic shield. Flat unglazed base.
H: 27.3cm W: 12.1cm Ft.W: 10.7cm
Arita, 1670–1690
1978.773

260 Vase
Tall vase of hexagonal section, with short neck left unglazed inside to take a cover. Decorated in underglaze blue with a tall flowering plant growing from rocks on each side of the body; peony scroll covering the shoulder. Flat unglazed base.
H: 32cm D: 19cm Ft.D: 13cm
Arita, late 17th–early 18th century
1978.724

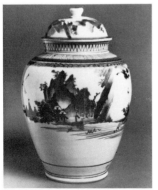

261 Jar with cover
High-shouldered jar with short neck and fitting domed knobbed cover. Decorated in underglaze blue with a continuous landscape of mountains, moored junks and drying nets; similar elements roughly repeated on the cover. Bands of formal ornament on shoulder and neck. Slightly gritty footrim.
H: 26.4cm D: 17.8cm Ft.D: 10.2cm
Arita, 1680–1700
1978.704

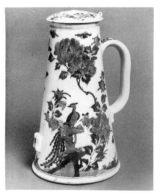

262　Coffee pot with cover

Coffee pot with handle and low bung hole in raised square opposite; slightly domed cover with a small loop to take a metal mount. Decorated in underglaze blue with pheasants, one perching and one flying, among branches of pomegranate and peony; sprays of peony and chrysanthemum on the cover. Slightly convex base.
H: 27.5cm D: 8.7cm Ft.D: 16.5cm
Arita, c. 1680
1978.878

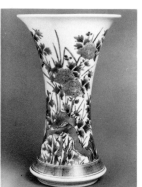

263　Vase

Trumpet-shaped beaker vase with wide flaring rim, and spreading base stepped back to a straight foot ring. Decorated in underglaze blue with clusters of peony and chrysanthemum growing from rocks.
H: 27.4cm D: 17.2cm Ft.D: 10.5cm
Arita, late 17th–early 18th century
1978.703

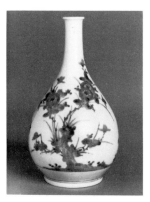

264　Vase

Bottle vase with rounded lip. Decorated in underglaze blue with two peony plants growing from rocks.
H: 26.5cm D: 15.3cm Ft.D: 9.8cm
Arita, late 17th century
1978.765

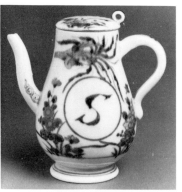

265　Ewer with cover

Small ewer from a cruet set, with slender spout and handle, and slightly domed cover with a loop at one side for a mount. Decorated in underglaze blue with a flying phoenix and flower sprays on either side, and a central initial 'S' in a circle. The base has a double 'skin' with a hole pierced in the outer layer.
H: 11.4cm D: 7.6cm Ft.D: 5.2cm
Arita, late 17th century
1978.718

266 Cup
Tall cup with slightly flaring rim. Decorated in underglaze blue with a clump of peonies growing from a rock on one side, and a leaping *shishi* on the other. Inside plain.
H: 10.8cm D: 10.2cm Ft.D: 4.4cm
Arita, *c.* 1700
1978.736

267 Dish
Large dish with wide flat everted rim. Decorated in underglaze blue: in the centre, a leaping *shishi* with a peony branch in its mouth; on the cavetto, two dragons chasing fiery pearls; on the rim, a border of peony scroll. Outside plain. Six spur marks to the base.
H: 6cm D: 39.5cm Ft.D: 20cm
Arita, early 18th century
1978.748

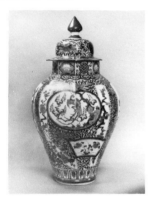

268 Jar with cover
Massive jar of octagonal section, and domed flat-rimmed cover with pointed knob. Decorated in underglaze blue with shaped panels containing various flowers and emblems, reserved against a dense ground of peonies and foliage. Cylindrical stepped-back foot ring.
H: 48.5cm D: 36.5cm Ft.D: 16.3cm
Arita, *c.* 1700
1978.777

269 Bottle with silver mounts
Bottle of hexagonal section, with sloping shoulder and narrow neck cut down and fitted with a silver mount. Decorated in underglaze blue with cranes and kingfishers perched and flying among pine trees, prunus and bamboo growing from rocks. Scrolled band on shoulder. Flat, unglazed base raised on three hemispherical feet. Silver mounts: Dutch, probably nineteenth century.
H: 23.2cm D: 13cm
Arita, *c.* 1700
1978.695

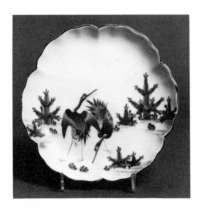

270　Dish
Saucer dish with brown-edged rim, petalled in six lobes. Decorated in underglaze blue with two cranes among young pine trees. Outside, a flower and scroll meander. On the base, three spur marks and a single circle.
H: 3cm D: 18.2cm Ft.D: 12cm
Arita, early 18th century
1978.713

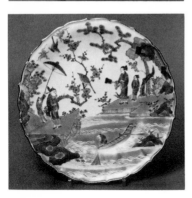

271　Dish
Saucer dish decorated in underglaze blue: two birds in the centre, and a solid blue border with leaves and tendrils, executed in wax-resist technique, in a darker blue and white. Outside, a continuous foliage scroll. On the base, two spur marks and a single blue circle.
H: 3cm D: 19.9cm Ft.D: 13cm
Arita, early 18th century
1978.762

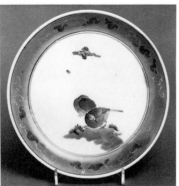

272　Dish
Large dish with fluted sides and slightly everted ten-petalled rim with brown edge. Decorated in underglaze blue with figures on the banks of a river, and a fisherman casting his net from a boat. Outside, a formal floral scroll. On the base, seven spur marks and a square *fuku* mark in a circle.
H: 5.6cm D: 31.5cm Ft.D: 19cm
Arita, early 18th century
1978.716

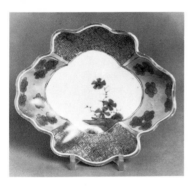

273　Dish
Small four-lobed saucer dish with wavy rim with flat brown edge. Decorated in underglaze blue with a flower spray in the centre panel, the cavetto divided into four panels, with diaper pattern and prunus blossom alternating in dark blue on a lighter blue ground. Outside, four leaf sprays. On the base, a cursive *fuku* mark in a square.
H: 3cm D: 16cm Ft.D: 9.7cm
Arita, early 18th century
1978.1925

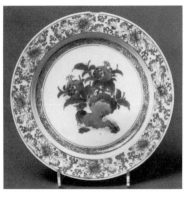

274 Dish
Saucer dish with flat everted rim. Decorated in underglaze blue with pomegranates growing from a rock in the centre, a narrow scroll border on the cavetto, and a peony wreath on the rim. Outside, three formal floral sprays. On the base, three spur marks and a *fuku* mark in a circle.
H: 2.2cm D: 19.4cm Ft.D: 10.8cm
Arita, early 18th century
1978.720

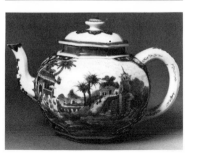

275 Dish
Saucer dish with everted rim. Decorated in underglaze blue with a tiger in the centre, and a wide border of flowers and leaves. Outside, a floral band. On the base, three spur marks and a seal mark in a circle.
H: 3cm D: 18.4cm Ft.D: 11.6cm
Arita, mid–late 18th century
1978.743

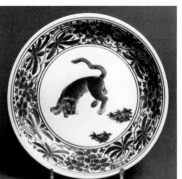

276 Teapot with cover
Teapot of rounded octagonal section, with knobbed cover. Decorated in underglaze blue with two panels containing scenes derived from European engravings; in between, a ground of blue with white lotus scroll in reserve. On the base, a six-character mark of Chenghua.
H: 18.4cm D: 24cm Ft.D: 9.8cm
Arita, *c.* 1800
1978.759

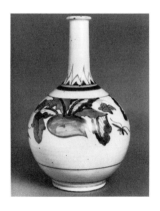

277 Vase
Bottle vase with tall neck and everted flanged rim. Decorated in underglaze blue with a *daikon* and two butterflies over the body, and a band of triangle ornament on the neck. Uneven foot ring.
H: 26.5cm D: 16.3cm Ft.D: 8.4cm
Hasami, late 18th–early 19th century
1978.728

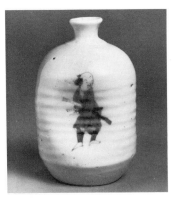

278 Bottle
Bottle of ovoid shape indented on three sides, the body horizontally ribbed round the middle, with a short flaring neck. Decorated in underglaze blue with figures on two sides, an actor with two swords and a Geisha girl, and the words, *JAPN SOYA*, on the third side.
H: 14.8cm D: 9.5cm Ft.D: 6.5cm
Hasami, early 19th century
1978.1251

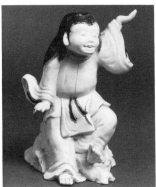

279 Figure
Figure of Gusho-jin, attendant on the God of Hell, sitting on a rock. Partly modelled and partly moulded; glazed over-all and decorated in overglaze brown enamel on hair, sleeves and sash. Flat unglazed base.
H: 14.5cm
Hirado, early 19th century
1978.498

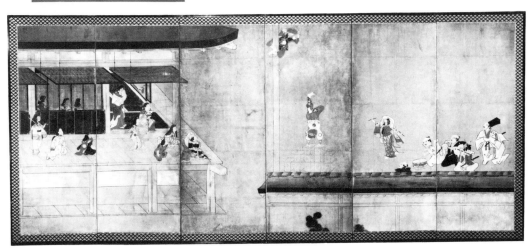

280 Screen
Six-fold screen. Ink and colours on paper. Two acrobats, wearing wigs of Shojo, and a group of musicians performing for the children of a rich household.
158cm × 366cm
Early Ukiyo-e school, *c.* 1660
1978.2532

Islamic ceramics

Although some pieces were hung on the upper staircase, and a few large dishes were displayed on *kilims* on the landing walls, the bulk of Gerald Reitlinger's Islamic collection was to be found in 'the Museum' in his house at Beckley, the room at the top of the first flight of stairs. His taste for Islamic pottery was as wide as the variety available on the market during his lifetime. This is shown in the following breakdown of his collection: Sasanio-Islamic (No. 281) and Samarran wares (Nos 282–285), sgraffiato (Nos 286, 294–297) and Samanid wares (Nos 288–293), Northern Iranian pre-Mongol (Nos 298–309), Il-Khanid (Nos 310–325) and Timurid wares (Nos 326–338), 'Kubachi' wares (Nos 339–342), Safavid blue and white (Nos 343–351), polychrome (Nos 352, 353) and 'Gombroon' wares (No. 354), various Egyptian wares (Nos 355–358), though no Egyptian lustre pieces, Syrian 'Raqqa' (Nos 362–370) and other types (Nos 359–361, 371–377), and Turkish 'Miletus' (No. 378) and Iznik wares (Nos 379–390). All these wares reflect Mr Reitlinger's interest in decoration, as, of course, do his Chinese and Japanese collections, and it is no surprise to discover relatively few examples of Saljuq white or monochrome wares in the collection, since these, like Chinese green or celadon wares, proved much less attractive to his eye.

Within such a wide-ranging collection there were inevitably particular emphases, which are in part reflected in the exhibition. First of all, there was a specific interest in Iraq. In the winter of 1930–31, Mr Reitlinger took part in an expedition to the site of Kish, in Iraq, sponsored jointly by Oxford University and the Field Museum of Natural History in Chicago. The following year he took part in excavations at another Iraqi site, Hira, sponsored by Oxford University. From these excavations he brought back large quantities of sherds and one or two almost complete objects (eg No. 286). The sherds were stored in the drawers below the cases in 'the Museum'. The Kish material provided the basis for an article which appeared in *Ars Islamica* in the year 1935, and for a contribution to the Third International Congress on Persian Art and Archaeology, held in Leningrad in 1935, which was subsequently published (see below). From the sherds in his collection, Kish appears to have yielded a greater amount of thirteenth–fourteenth-century wares than Abbasid pieces, and the rest of the collection shows that Mr Reitlinger was a great deal more interested in the former period than in the latter: Samarran wares are rather poorly represented compared to the period from 1150 onwards. It

was probably this material from Iraq which was the inspiration for many of Mr Reitlinger's subsequent purchases of Syrian and Iranian wares of the period, the second important emphasis which should be noted in his collection. Of Syrian wares, he put together an unusually large collection of objects, showing his particular partiality for underglaze-painted 'Raqqa' wares, but also including some notable pieces of fourteenth–fifteenth-century Syrian blue and white (No. 374) and good examples of the Damascus sixteenth-century style (No. 377). On the Iranian side, he put together what is probably the finest collection anywhere of fourteenth and fifteenth-century wares. The Ashmolean Museum was thus able to put on an exhibition using the Reitlinger collection in June 1977, which showed clearly the gradual decay in design during the fourteenth and fifteenth centuries, and as a result emphasized the importance of the arrival of Chinese blue and white designs for the Iranian ceramic industry, from the late fourteenth century onwards. The collection also demonstrates the close connection between Syrian, Iraqi and Iranian ceramic designs under the Il-Khanids, thus confirming what is already evident in metalworking styles. Again, Mr Reitlinger used his collection as a vehicle for publication, and his articles on 'Varamin' and 'Sultanabad' wares, published in 1938 and 1944–45 (see below), were pioneer studies which still retain great importance for students of Islamic pottery.

Gerald Reitlinger obviously saw much Islamic pottery in terms of its Far Eastern equivalents, particularly, of course, Safavid blue and white. His catalogue cards on the Iranian pieces constantly refer to the equivalent Chinese designs, and blue and white and the Chinese connection form a third important element in his Islamic collection. This was the basis for another exhibition at the Ashmolean Museum, in January 1980. With his eye for the rare or unusual, he acquired pieces of fifteenth–sixteenth-century date which offer clues about the development of the Chinese style in Iran. Subsequently, he put together a remarkable collection of Safavid blue and white—not as extensive, certainly, as that acquired by Murdoch-Smith in the nineteenth century for the Victoria and Albert Museum, but a collection of major importance by any other standards. The great dishes (Nos 347–351) and great bowl (No. 346) are as magnificent as any known, and the Chinese Transitional style can be nowhere more movingly reflected than in one of the hookah bases in the collection (No. 345).

Not a single piece of the collection was lost in the fire. However, the water from the firemen's hoses dissolved much of the glue and plaster used to repair many of the earlier Islamic objects. A great deal of repair work has therefore had to be redone, and much still remains to be completed. The number of his gold-painted plaster repairs left is now, perhaps mercifully, small, but little can be done to resurrect glaze surfaces, once iridescent, and subsequently rather brutally attacked with scraper and steel wool prior to a liberal coating of varnish. Fortunately the number of objects so treated is small, and detracts little from a collection which reflects not only the talents of ceramic decorators of earlier times, but also the unerring eye and delightful taste of its collector.

As noted above, Gerald Reitlinger made a significant scholarly contribution to the study of Islamic ceramics. The articles in which his views were published are as follows: 'Islamic Pottery from Kish', *Ars Islamica* No. 2, 1935, pp 198–218; 'Islamic Glazed Pottery from Kish', Third International Congress on Persian Art and Archaeology, Leningrad 1935, pp 197–201; 'The Interim Period in Persian Pottery: an Essay in Chronological Revision', *Ars Islamica* No. 5, 1938, pp 155–178; 'Sultanabad: Classification and Chronology', *Transactions of the Oriental Ceramic Society*, vol. 20, 1944–45, pp 25–34.

J. W. Allan

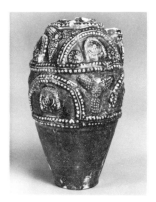

281 Ewer fragment

Body of a ewer, the neck and handle missing. Thick cream earthenware with relief decoration under a green-blue glaze: two bands with bead borders contain beaded arches separated by a rosette with three beaded leaves; each arch contains three rosettes, the central one over a crescent, within a subsidiary arch. Concave glazed base.
H: 26cm D: 16.3cm Ft.D: 7.5cm
Iraq, *c*. 900
1978.2242

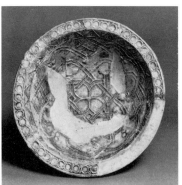

282 Bowl

Earthenware bowl with rounded body and flat rim. Decorated inside in moulded relief with interlacing geometrical forms within a border of triangles, a border of circles at the rim; outside plain; within the foot ring, an eight-pointed star encircled by interlacing bands. Green splashes inside, and a yellow-brown glaze over-all.
H: 4.9cm D: 18.2cm Ft.D: 5.8cm
Iraq, 9th century
1978.2143

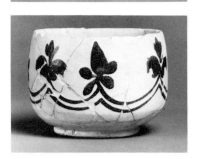

283 Bowl

Deep earthenware bowl with rounded, inward-sloping sides. Decorated outside with an opaque white glaze, and eight blue palmettes of alternating form joined by a double stem; the inside plain. Low foot ring. Partially glazed base.
H: 9.5cm D: 13cm Ft.D: 8.4cm
Iraq, 9th–10th century
1978.2137

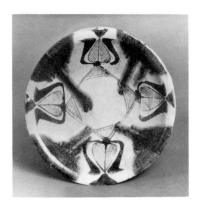

284 Bowl

Bowl of cream earthenware, with rounded sides and everted rim. Decorated with a white glaze, and inside, with four green splashes and four blue palmettes around a central blue square. Low foot ring.
H: 6cm D:20.2cm Ft.D: 8cm
Iraq, 9th–10th century
1978.2141

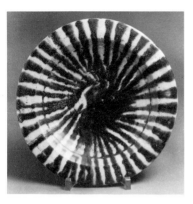

285 Dish

Dish of buff earthenware, with shallow rounded body, flat rim and three conical feet. Decorated in green in a slightly milky glaze, with radiating stripes inside, and splashes outside.
H: 2.7cm D: 21.5cm
Iraq, 10th century
1978.1763

286 Bowl

Large bowl of buff earthenware, with rounded sides, a single flute outside the rim. Decorated inside under a colourless glaze with an incised design of two circles containing arabesques, arabesques on either side, and with green and purple dots on white slip. Outside plain, glazed. Thick foot ring. Excavated by Gerald Reitlinger at Sha'al Ghazna, between Babylon and Kish, December 1930.
H: 11cm D: 36.5cm Ft.D: 14.5cm
Iraq, 11th century
1978.2122

287 Water jar fragment

Part of the neck and shoulder of a water jar. Unglazed earthenware, with barbotine decoration of animal and human heads, stylised arabesques, and a single quasi-human figure.
H: 26.5cm
Northern Iraq, mid 12th century
1978.2253

288 Bowl

Bowl of buff earthenware, with almost straight flaring sides. Decorated inside in purple and red slips under a colourless glaze, with a kufic inscription round the sides. Outside plain, glazed. Pad foot and flat base.
H: 6.8cm D: 21.3cm Ft.D: 8.5cm
North-east Iran or Transoxania, 10th–11th century
1978.1758

289 Bowl

Bowl of pink earthenware, with straight flaring sides and rounded everted lip. Decorated inside in purple and khaki slips with turquoise on white under a colourless glaze: an eight-pointed star with alternating pseudo-kufic inscriptions and diamond designs. Outside plain, unglazed. Low foot ring, with pad base inside.
H: 7.8cm D: 28.5cm Ft.D: 12cm
North-east Iran, 10th–11th century
1978.2124

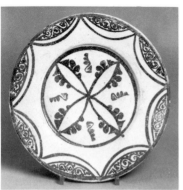

290 Plate

Plate of pink earthenware, with wide everted rim, the edge turned up and slightly rounded. Decorated inside in purple and brown slips on white under a colourless glaze , with a looped cross in the centre, surrounded by an eight-pointed, concave-sided star. Outside plain, unglazed. Flat base.
H: 3.1cm D: 31cm Ft.D: 20cm
North-east Iran, 10th–11th century
1978.1754

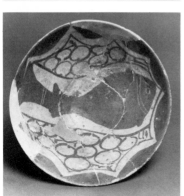

291 Bowl

Bowl of pink earthenware, with rounded sides. Decorated inside in khaki and green slips on white under a colourless glaze, with a fish inside a ten-pointed, concave-sided star. Outside plain, unglazed. Low foot ring, with pad base inside.
H: 6.9cm D: 17.5cm Ft.D: 7cm
North-east Iran, 10th–11th century
1978.2116

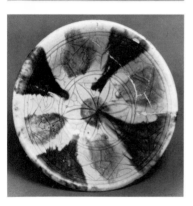

292 Bowl

Bowl of pink earthenware, with rounded sides and everted rim. Decorated on white slip under a colourless glaze: inside, in green and brown, with an incised central six-pointed rosette, surrounded by birds and mountains; outside, with green splashes. Low foot ring.
H: 6.2cm D: 22.5cm Ft.D: 10.4cm
North-east Iran, 11th century
1978.1759

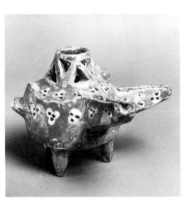

293 Lamp
Lamp of buff earthenware, with round body, pierced conical top, three conical feet, three spouts and a handle (largely missing). Decorated on a red slip ground under a yellowish glaze, with groups of triple black and white dots.
H: 9cm D: 7.3cm
North-east Iran, 10th–11th century
1978.2119

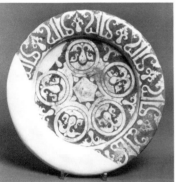

294 Dish
Dish of reddish earthenware, with slightly concave centre and wide, upward-sloping, rounded rim. Covered over-all with white slip under a yellowish glaze; inside, the slip carved away to leave in the centre, five circles with doves on either side of a plant form, and on the rim, pseudo-kufic motifs alternating with palmettes. Outside plain. Low foot ring.
H: 4.4cm D: 29.5cm Ft.D 13.6cm
Western Iran, 12th century
1978.2134

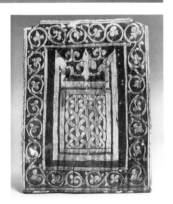

295 Tile
Rectangular tile of pink earthenware. Covered with white slip under a green glaze, the slip carved away to leave a central design recalling the end of a cenotaph, with a border of bold arabesque.
H: 38cm W: 29.5cm
Western Iran, 12th century
1978.1547

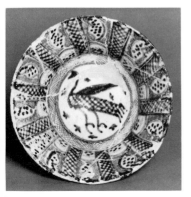

296 Bowl
Bowl of reddish earthenware, with rounded lower body and outward-curving upper body. Covered with white slip under a colourless glaze on inside and upper part of outside. Decorated inside in green, with a bird within an incised criss-cross border; the sides divided into ten panels, each containing a spotted leaf; outside, four large green splashes. Signed on the inside, *'amal-i Sayyid Rustam Muḥammad'*. Flaring foot ring.
H: 9.5cm D: 20.5cm Ft.D: 7.6cm
Western Iran, 'Amol' ware, 14th century
1978.2132

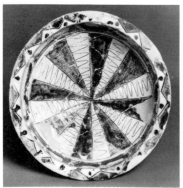

297 Bowl
Bowl of pink earthenware, with shallow flaring lower body, vertical upper body and flat everted rim. Decorated inside in green and brown on white slip under a colourless glaze, with an incised eight-petalled rosette within curvilinear and rectilinear borders; outside, the upper body with brown lines and circles on white slip, unglazed. Foot ring with shallow conical interior.
H: 9.2cm D: 24cm Ft.D: 8.2cm
North-west Iran, 13th–14th century
1978.1745

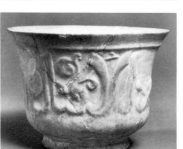

298 Cup
Cup of frit ware, with slightly flaring sides and flared rim. Under a colourless glaze, a moulded naskhi inscription, *al-ʿizz wa ʾl'iqbāl waʾl-dawla lisā(hibihi)*, 'glory, prosperity and fortune to its owner'. Low foot ring.
H: 8.4cm D: 12.5cm Ft.D: 6.6cm
Northern Iran, 12th century
1978.2225

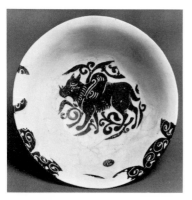

299 Bowl
Bowl of fine pinkish frit ware, with rounded sides and slightly everted lip. Decorated inside in brown slip on white slip under a colourless glaze, with a winged animal against stems, details incised; on the rim, half discs of slip with incised stems, the area between originally decorated with small rosettes. Outside plain, glazed. Tall foot ring.
H: 8.2cm D: 22.3cm Ft.D: 8.1cm
Northern Iran, 12th century
1978.2260

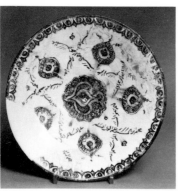

300 Dish
Dish of frit ware, with straight flaring sides. Decorated in black and blue under a transparent greenish glaze, covering entire body including base. Inside, a central rosette surrounded by five pear-shaped medallions, and naskhi script between; outside, five large medallions in lobed panels. Low foot ring.
H: 6.4cm D: 29.5cm Ft.D: 12.9cm
Northern Iran, late 12th–early 13th century
1978.2307

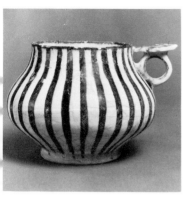

301 Tankard

Tankard of frit ware, with bulbous body and a latch handle from another similar piece. Decorated with twenty-seven blue stripes under a colourless glaze; inside plain, glazed. Low foot ring.
H: 12cm D: 16cm Ft.D: 8.6cm
Northern Iran, late 12th–early 13th century
1978.2347

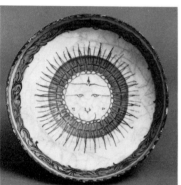

302 Bowl

Bowl of frit ware, with rounded lower body, vertical upper body. Decorated in blue and black under a colourless glaze: inside, a sunface surrounded by a band of 'waterweed' decoration; outside, eight three-leafed plants in black. Tall splayed foot ring. (Monochrome plate p. 108)
H: 10cm D: 19.3cm Ft.D: 7.6cm
Northern Iran, late 12th–early 13th century
1978.2311

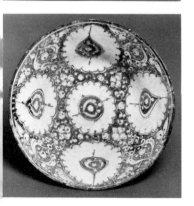

303 Bowl

Bowl of frit ware, with truncated conical body. Decorated in blue and black under a colourless glaze; inside, five medallions reserved in white, each with a palmette in the centre, arabesques between; outside, sixteen pseudo-kufic compartments with curving stems. Tall vertical foot ring. (Monochrome plate p. 108)
H: 8.3cm D: 20.2cm Ft.D: 8.3cm
Northern Iran, 13th century
1978.2339

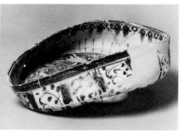

304 Kiln waster

Kiln waster, originally a frit ware bowl with rounded lower body and vertical upper body. Decorated in blue and black under a thick greenish glaze, with a complex arabesque design inside; outside, fifteen compartments, each with a scrolling stem. Low foot ring.
H: 9.3cm original D: 20.3cm Ft.D: 11.5cm
Northern Iran, 13th century
1978.2261

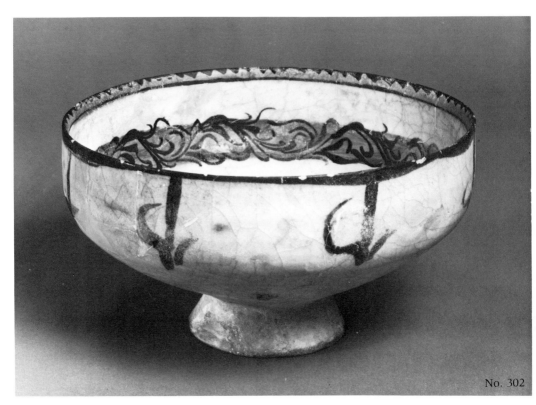

No. 302

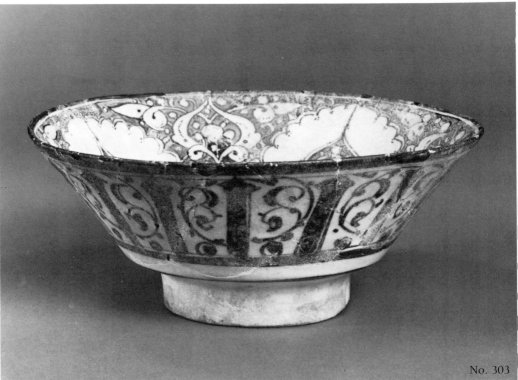

No. 303

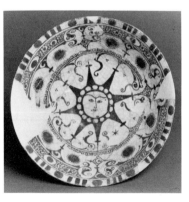

305 Bowl

Bowl of frit ware, with rounded flaring sides. Decorated in brown lustre over a colourless glaze, inside, with a central sunface and eight rays, and four concentric borders on the sides; outside, pseudo-naskhi script. Straight foot ring. (Monochrome plate p. 111)
H: 8cm D: 19.2cm Ft.D: 6.6cm
Northern Iran, Kashan, late 12th century
1978.2256

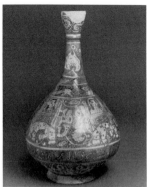

306 Bottle

Pear-shaped frit ware bottle. Decorated in yellow-brown lustre over a colourless glaze, with a large band of four elephants with howdahs, between a band of three hares and naskhi inscription; bands of vegetal ornament at rim, neck and foot. Low splayed foot ring.
H: 25.5cm D: 15cm Ft.D: 8.2cm
Northern Iran, Kashan, late 12th–early 13th century
1978.2243

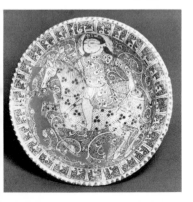

307 Bowl

Bowl of frit ware, with rounded flaring sides, ridged below a slightly everted lip. Decorated in yellowish lustre over a colourless glaze, inside, with a horseman against a heavily scrolled ground, surrounded by a pseudo-kufic border; outside, pseudo-naskhi. Tall straight foot ring.
H: 9cm D: 21.5cm Ft.D: 7.6cm
Northern Iran, Kashan, early 13th century
1978.2330

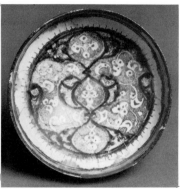

308 Bowl

Bowl of frit ware, with rounded lower body and vertical upper body. Covered with a colourless glaze, decorated in underglaze blue outline and golden lustre, with an arabesque design and a border of naskhi inscription inside, and a pseudo-kufic design outside. Tall flaring foot ring.
H: 7.2cm D: 14.2cm Ft.D: 6cm
Northern Iran, Kashan, early 13th century
1978.2266

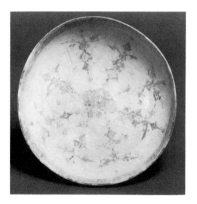

309 Bowl

Bowl of frit ware, with rounded lower body and vertical upper body, ridged below the rim. Covered with a milky glaze, decorated in underglaze blue and overglaze red and gold, with a central rosette and eight radiating plant-like motifs within a pseudo-kufic border inside; outside, the remains of a naskhi inscription. Low flaring foot ring.
H: 9cm D: 21cm Ft.D: 9cm
Northern Iran, late 12th–early 13th century
1978.2340

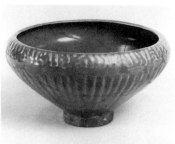

310 Bowl

Bowl of frit ware, with flaring fluted sides and inward-curving rim. Decorated in moulded relief under a green imitation-celadon glaze, with three swimming fishes inside, and a band of inscription round the rim outside. Tall vertical foot ring.
H: 11.6cm D: 22cm Ft.D: 6.8cm
Northern Iran, 'Sultanabad' ware, late 13th–early 14th century
1978.1647

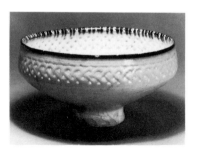

311 Bowl

Bowl of frit ware, with flaring lower body and slightly inward-sloping upper body; a band of pierced strapwork design below the rim. Decorated inside in blue, purple and green under a colourless glaze, with a central roundel containing a duck beneath a tree; a border of underglaze blue and black on the rim. Tall slightly flaring foot ring. Outside plain, glazed.
H: 10cm D: 20cm Ft.D: 6.6cm
Northern Iran, 'Sultanabad' ware, late 13th century
1978.1639

312 Bowl

Bowl of frit ware, with rounded sides. Decorated under a colourless glaze, with a blue maltese cross and greenish-black triangles inside, and with lotus petal panelling in blue and black outside. Tall foot ring. (Monochrome plate p. 111)
H: 10cm D: 21.8cm Ft.D: 6.5cm
Northern Iran, 'Sultanabad' ware, late 13th century
1978.1638

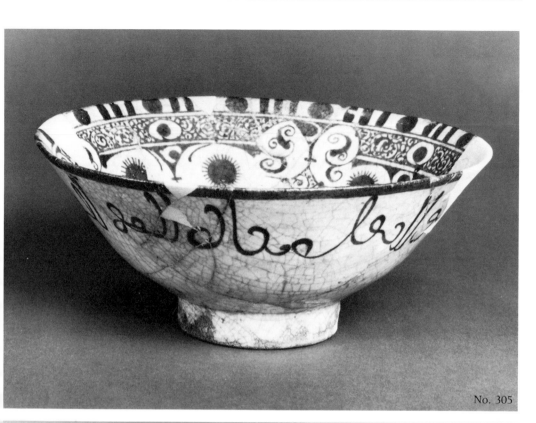

No. 305

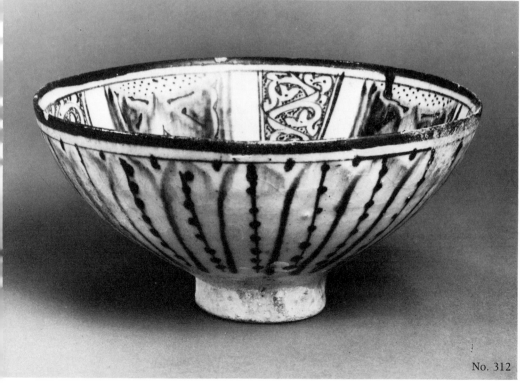

No. 312

313　Bowl

Bowl of frit ware, with rounded sides and everted lip.
Decorated in blue and greenish black under a colourless
glaze: inside, a central plaited rosette with eight radiating
arabesque panels; outside, pairs of alternating blue and
black stripes. Tall foot ring.
H: 9.7cm D: 21.4cm Ft.D: 6cm
Northern Iran, 'Sultanabad' ware, late 13th century
1978.1595

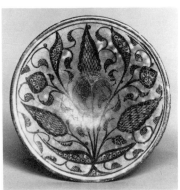

314　Dish

Small frit ware dish with flaring sides. Decorated in black
under a turquoise glaze: inside, a plant with leaves and
tendrils; outside, pairs of stripes. Low foot ring.
H: 6cm D: 20.5cm Ft.D: 6.5cm
Northern Iran, 'Sultanabad' ware, late 13th century
1978.1645

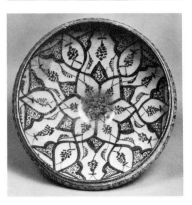

315　Bowl

Bowl of frit ware, with flaring sides and inward-curving
rim. Decorated in black under a turquoise glaze: inside, an
arabesque design centred on a six-pointed star: outside,
bands of small rosettes; pseudo-inscription round the rim.
Tall narrow foot ring.
H: 10.5cm D:21.3cm Ft.D: 6.7cm
Northern Iran, 'Sultanabad' ware, late 13th century
1978.1614

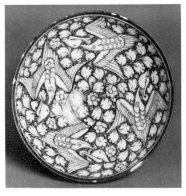

316　Bowl

Bowl of frit ware, with rounded sides. Decorated under a
colourless glaze in white against a brown ground, inside,
with four phoenixes among leaves; outside, with white
arcades. Narrow foot ring and glazed base.
H: 9.5cm D: 20.8cm Ft.D: 6.5cm
Northern Iran , 'Sultanabad' ware, early 14th century
1978.1637

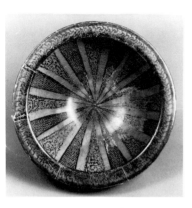

317 Bowl

Bowl of buff earthenware, with flaring lower body and inward-curving upper body; flat, overhanging rim. Decorated in black under a turquoise glaze: inside, eight radiating panels of zig-zag and eight of arabesque; outside, bands of fish, birds in roundels and pseudo-naskhi inscription; plaiting on rim. Low foot ring.
H: 13.5cm D: 27.7cm Ft.D: 11.3cm
Northern Iran, 'Sultanabad' ware, late 13th–early 14th century
1978.1587

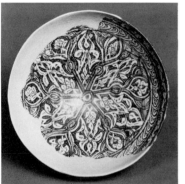

318 Bowl

Bowl of buff frit ware, the rounded sides moulded with fluting. Decorated in gold lustre over a slightly milky glaze, with underglaze blue and turquoise: inside, an elaborate six-pointed star design with palmettes, within two borders; outside, panels of whirls or pseudo-naskhi. Narrow foot ring.
H: 10.5cm D: 22.1cm Ft.D: 6.5cm
Northern Iran, 'Sultanabad' ware, late 13th–early 14th century
1978.1686

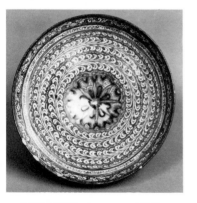

319 Bowl

Bowl of pale buff frit ware, the rounded sides moulded with fluting. Decorated in gold lustre over a slightly milky glaze, with underglaze blue and turquoise: inside, a central rosette with five encircling borders; outside, panels of herringbone pattern or pseudo-naskhi. Narrow foot ring.
H: 10cm D: 21.4cm Ft.D: 6.8cm
Northern Iran, 'Sultanabad' ware, late 13th–early 14th century
1978.1640

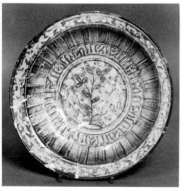

320 Dish

Dish of frit ware, with rounded sides and slightly sloping rim with upturned lip. Decorated in brown lustre over a colourless glaze, with underglaze blue and turquoise: inside, a plant with two birds, encircled by borders of pseudo-naskhi inscription, panelling and leaves; outside, a band of palmettes with a naskhi inscription above. Low foot ring.
H: 6.1cm D: 33.5cm Ft.D: 18.4cm
Northern Iran, 'Sultanabad' ware, late 13th–early 14th century
1978.1669

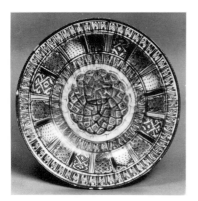

321 Dish

Dish of frit ware, with rounded sides and slightly sloping rim with upturned lip. Decorated in blue, turquoise and black under a colourless glaze: in the centre, a plaited rosette within three bands of panelling; outside, pairs of alternating black and blue stripes. Low foot ring. (Colour plate V)

H: 7.8cm D: 34.1cm Ft.D: 14.5cm
Northern Iran, 'Sultanabad' ware, late 13th–early 14th century
1978.1609

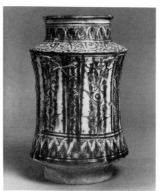

322 Albarello

Albarello-shaped jar with pale buff body. Decorated in blue and black under a colourless glaze, with twelve alternating panels of arabesque round the body, pseudo-naskhi inscription at the shoulder, a decorative band round neck and lower body. Foot ring not original.

H: 24.5cm D: 15.5cm Ft.D: 11cm
Northern Iran, 'Sultanabad' ware, or Syria, late 13th–early 14th century
1978.1683

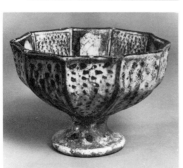

323 Stem cup

Decagonal stem cup with pinkish body. Decorated in black, blue and turquoise under a colourless glaze, with radiating panels, alternately speckled inside; outside speckled. Tall splayed foot ring.

H: 9.4cm D: 14cm Ft.D: 6.7cm
Northern Iran, 14th century
1978.1621

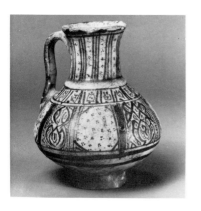

324 Jug

Jug of buff earthenware, with handle, bulbous body, and waisted neck ridged at the base. Decorated in black, blue, turquoise and brown under a colourless glaze, with eight panels alternately filled with arabesques and dots; panelling on shoulder and neck. Low foot ring.

H: 15.5cm D: 12.8cm Ft.D: 6cm
Northern Iran, late 13th–early 14th century
1978.1658

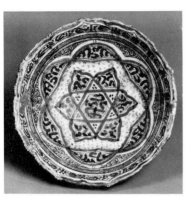

325 Bowl

Bowl of buff earthenware, with rounded body and flaring lip. Decorated in black and blue under a colourless glaze, with a six-pointed star design within hatched and panelled borders inside; outside, arcading beneath a zig-zag band. Low foot ring.
H: 10.4cm D: 26.7cm Ft.D: 8.1cm
Northern Iran, 14th century
1978.1600

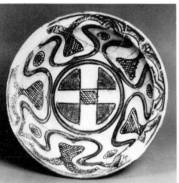

326 Bowl

Large bowl of buff earthenware, with rounded body and everted rim with upturned lip. Decorated inside in black, turquoise and purple under a colourless glaze, with a central cross form within five ogival panels; outside plain, largely unglazed. Low foot ring.
H: 9.2cm D: 33.6cm Ft.D: 11.7cm
Northern Iran, 'Varamin' ware, late 14th–early 15th century
1978.1613

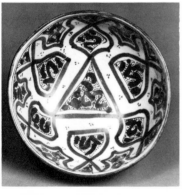

327 Bowl

Bowl of frit ware, with rounded lower body and straight flaring upper body. Decorated in black and blue under a colourless glaze, with six medallions around a triangle; outside, eleven black stripes. Tall vertical foot ring.
H: 8.6cm D: 17.5cm Ft.D: 6cm
Northern Iran, 'Varamin' ware, late 14th–early 15th century
1978.1656

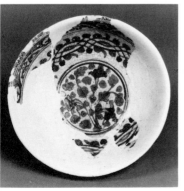

328 Bowl

Fragmentary bowl of buff earthenware, with rounded sides and slightly everted lip. Decorated inside in blue and brown under a colourless crackled glaze, with a plant form in the centre, surrounded by an arabesque band and vegetal border; outside plain, glazed. Tall foot ring. Found by Gerald Reitlinger at Sultaniyah, November 1931.
H: 12.5cm D: 24.8cm Ft.D: 9.5cm
Northern Iran, late 14th–early 15th century
1978.1590

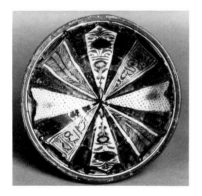

329 Bowl

Bowl of white earthenware, pink at the foot, with rounded lower body and outward-curving upper body. Decorated in greenish-black, blue and turquoise under a colourless glaze: inside, eight radiating panels in four different designs; outside, alternate blue and greenish-black stripes. Low foot ring.
H: 10.5cm D: 22.7cm Ft.D 7.9cm
Northern Iran, 'Varamin' ware, late 14th–early 15th century
1978.1598

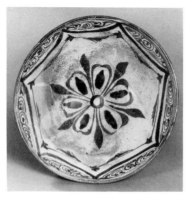

330 Bowl

Bowl of buff earthenware, with rounded sides. Decorated inside in brown and blue on off-white slip under a colourless glaze, with a central six-petalled rosette within a seven-sided border; outside plain, with white slip and glaze covering the upper part only. Low foot ring.
H: 10.4cm D: 22.9cm Ft.D: 7.8cm
Northern Iran, 'Varamin' ware, late 14th–early 15th century
1978.1592

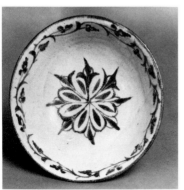

331 Bowl

Bowl of buff earthenware, with rounded sides and everted lip. Decorated inside in blue on white slip under a colourless glaze, with a central eight-petalled rosette surrounded by a stem and leaf border below the rim; outside plain, with white slip and glaze covering the upper part only. Narrow foot ring.
H: 10.2cm D: 23cm Ft.D: 7.7cm
Northern Iran, 'Varamin' ware, late 14th–early 15th century
1978.1599

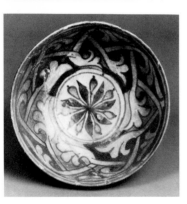

332 Bowl

Bowl of buff earthenware, with rounded lower body and straight flaring upper body. Decorated in black and turquoise on white slip under a colourless, though badly-stained, glaze: inside, a central seven-petalled rosette surrounded by bold interlaced tendrils; outside, sixteen black stripes. Low foot ring. (Monochrome plate p. 117)
H: 10.3cm D: 20.7cm Ft.D: 7.5cm
Northern Iran, 'Varamin' ware, 15th century
1978.1591

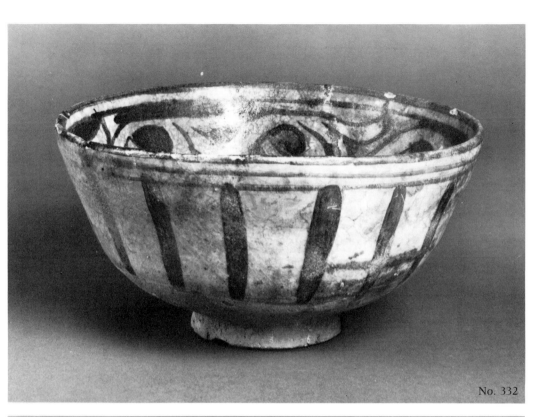

No. 332

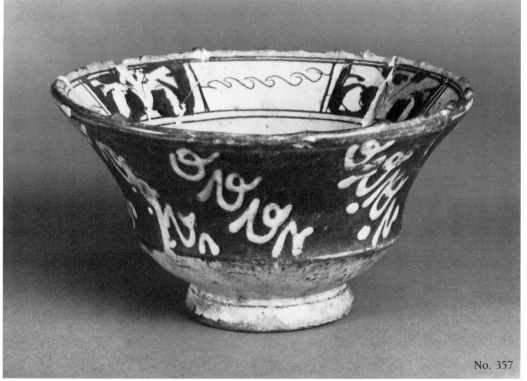

No. 357

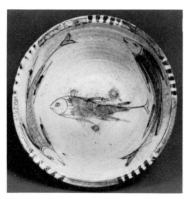

333 Bowl

Bowl of buff earthenware, with rounded flaring sides and everted lip. Decorated in brown, turquoise and purple on white slip under a slightly milky glaze, with three flying fishes inside; striped rim; outside plain, unglazed. Wide flat foot ring.

H: 11.3cm D: 26.3cm Ft.D: 10cm
Northern Iran, 'Varamin' ware, 15th century or later
1978.1674

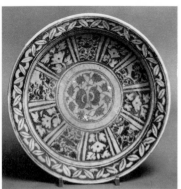

334 Dish

Dish of frit ware, with rounded body and flaring rim. Decorated in blue under a turquoise glaze: inside, peonies in a central medallion surrounded by ten alternating vegetal panels, and leaf and stem interlace on the rim; outside, a Chinese-style meander. Low thick foot ring.

H: 8.5cm D:30.2cm Ft.D: 10.2cm
Iran, second half of 15th century
1978.1608

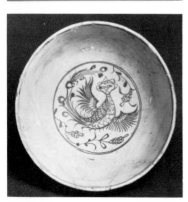

335 Bowl

Bowl of frit ware, with rounded sides. Decorated in blue under a colourless glaze, with a phoenix in a central roundel inside; outside, a Chinese-style meander. Low foot ring.

H: 9.5cm D: 18.2cm Ft.D: 9.5cm
Iran, late 15th–early 16th century
1978.1602

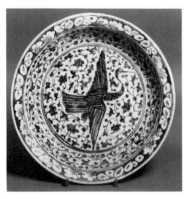

336 Dish

Dish of frit ware, with rounded sides and everted rim. Decorated in black and blue under a colourless glaze: in the centre, a flying crane amid floral scrolls, with floral scrolls on the cavetto and a rock and wave design on the rim; outside, a band of whorls. Low foot ring.

H: 7.1cm D: 35cm Ft.D 18.6cm
Iran, late 15th–early 16th century
1978.1605

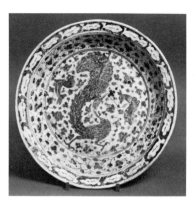

337 Dish

Dish of frit ware, with rounded sides and everted rim. Decorated in black and blue under a colourless glaze, with a central design of a peacock and two deer amid floral scrolls inside; floral scrolls on the cavetto, and a degraded rock and wave design on the rim; outside, a band of whorls. Low foot ring.
H: 7.4cm D: 33.6cm Ft.D: 19cm
Iran, late 15th–early 16th century
1978.1604

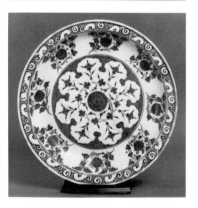

338 Dish

Saucer dish of frit ware, with rounded sides and everted rim. Decorated in blue, black, purple and turquoise under a colourless glaze, with a central design of a turbanned figure between two cypresses inside, and blue discs around the rim; outside, a band of whorls. Low foot ring.
H: 4.5cm D: 17.8cm Ft.D: 6cm
Iran, late 15th–early 16th century
1978.1655

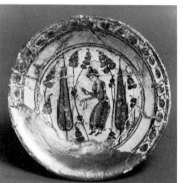

339 Dish

Dish of heavy frit ware, with rounded sides, flat rim and upturned lip. Decorated in blue under a colourless glaze; inside, a central flower within an eight-lobed rosette reserved in white; on the cavetto, eight floral sprays, and degraded rock and wave pattern on rim; outside, a meander with spiky leaves and eight round flowers. Low inward-sloping foot ring; the base glazed, except for a disc in the centre.
H: 8cm D: 42cm Ft.D: 26.3cm
Iran, 'Kubachi' ware, first half of 16th century
1978.1484

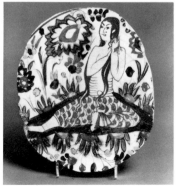

340 Bowl fragment

Base of a bowl of buff earthenware. Decorated in black, blue, red, green and beige on white slip under a colourless glaze, with a seated girl combing her hair amid flowers. Low foot ring.
D: 22cm Ft.D: 14.5cm
Iran, 'Kubachi' ware, late 16th–early 17th century
1978.1540

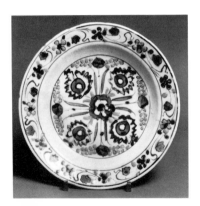

341 Dish

Dish of frit ware, with slightly rounded sides and flaring rim. Decorated inside in blackish-green, brown, blue, turquoise, red and beige under a colourless glaze, with five blossoms in the centre, and a floral meander on the rim. Outside plain. Low foot ring.
H: 5.7cm D:26.5cm Ft.D:8.2cm
Iran, 'Kubachi' ware, 17th century
1978.1734

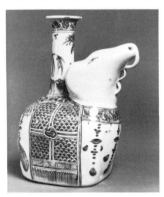

342 Dish

Dish of frit ware, with rounded sides and everted lip. Decorated in black and slate blue under a transparent greenish glaze: inside, a curious floral design of boat-like appearance; outside, five groups of criss-cross lines. Low foot ring; glazed base.
H: 7.5cm D: 31.6cm Ft.D: 13.3cm
Iran, late 17th–early 18th century
1978.1782

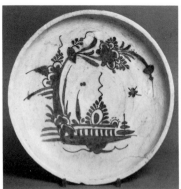

343 Kendi

Kendi of soft-paste porcelain, in the form of an elephant. Decorated in underglaze blue and black, the elephant's trappings with fish scale or meander patterns; on the neck, a bird and bough, lappets and meanders. Flat base.
H: 21.5cm L: 15.2cm
Iran, first half of 17th century
1978.1700

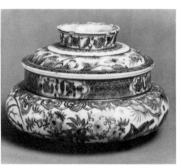

344 Jar

Jar of soft-paste porcelain, imitating a metal lidded bowl with bulbous body and flaring mouth. Decorated in blue and black under a colourless glaze, with ducks and birds amid bamboo and landscape on the body, a similar design with bees on the shoulder; encircling bands of meander, lappets, fish scale and diaper patterns. Low foot ring; glazed base.
H: 12cm D: 18.4cm Ft.D: 10cm
Iran, first half of 17th century
1978.1722

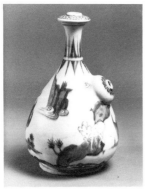

345 Hookah base

Hookah base of soft-paste porcelain, with pear-shaped body. Decorated in shades of blue and black under a colourless glaze, with two figures and two animals in a landscape of rocks, pine trees and clouds in Ming Transitional style: *ruyi* lappets above foot; lappets around nipple; diaper pattern on mouth. Low foot ring; base glazed, with imitation Chinese mark.
H: 27.5cm D: 16.8cm Ft.D: 11.4cm
Iran, late 17th century
1978.1703

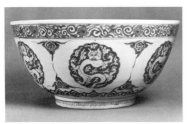

346 Bowl

Bowl of soft-paste porcelain, with rounded sides. Decorated in blue and black under a colourless glaze: inside, a demon-headed dragon in a medallion, and borders of *ruyi* lappets and meander; outside, six such medallions and similar borders. Low foot ring; base glazed, with imitation Chinese mark.
H: 19cm D: 39cm Ft.D: 18.3cm
Iran, 17th century
1978.1778

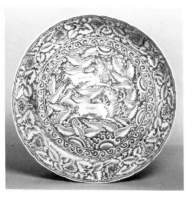

347 Dish

Dish of soft-paste porcelain, with deep rounded sides and flaring rim. Decorated in blue and black under a colourless glaze: inside, two ponies amid waves surrounded by an elaborate floral arabesque; outside, three birds on boughs with butterflies. Inward-sloping foot ring; base glazed, with imitation Chinese mark.
H: 10.5cm D: 42.2cm Ft.D: 21.3cm
Iran, late 17th century
1978.2167

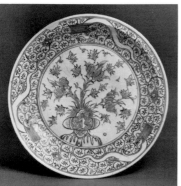

348 Dish

Dish of soft-paste porcelain, with rounded sides and everted rim. Decorated in blue under a colourless glaze: inside, peonies growing from a tree stump with three dragons against a scroll ground; outside, three flowering stems. Low foot ring; the base glazed, with three imitation Chinese marks.
H: 7cm D: 44.6cm Ft.D: 27.5cm
Iran, late 17th–early 18th century
1978.2168

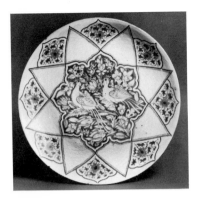

349 Dish

Dish of soft-paste porcelain, with rounded sides. Decorated inside with incised lines and blue under a colourless glaze: two pheasants amid flowers within an eight-pointed medallion, surrounded by an eight-pointed star with scrolls between the points; outside glazed blue. Low foot ring; glazed base. (Colour plate VI)
H: 7.8cm D: 48cm Ft.D: 27.5cm
Iran, late 17th–early 18th century
1978.2169

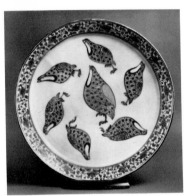

350 Dish

Dish of soft-paste porcelain, with rounded body and flaring rim. Decorated in shades of blue under a colourless glaze: inside, seven partridges within a meander border; outside, degraded scrolls. Inward-sloping foot ring; glazed base, with sunken centre and six spur marks.
H: 9cm D: 44.5cm Ft.D: 18cm
Iran, 18th century
1978.1783

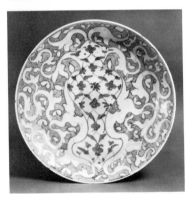

351 Dish

Dish of soft-paste porcelain, with rounded body and flaring rim. Decorated in two shades of blue under a colourless glaze: inside, a vase against white stems on a hatched ground; outside, stems and flowers. Inward-sloping foot ring; glazed base, with sunken centre and six spur marks.
H: 8.4cm D: 46.3cm Ft.D: 18.3cm
Iran, 18th century
1978.2321

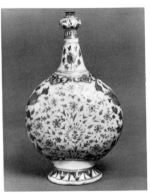

352 Bottle

Bottle of soft-paste porcelain, with flattened globular body and bulb-topped neck. Decorated in blue, yellowish-red and green under a colourless glaze: green and red flower sprays on the flattened sides, blue flower sprays on the narrow sides, beneath a *ruyi* lappet border; two flower sprays on neck; bands of scrolls and panelling on upper neck, mouth and foot. Splayed foot ring; glazed base with protruding angular ridge across it.
H: 35.5cm D: 21.6cm Ft.D: 12cm
Iran, late 17th–early 18th century
1978.1709

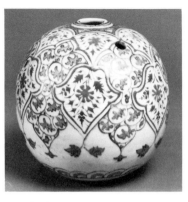

353 Hookah base

Almost spherical hookah base of soft-paste porcelain. Decorated in blue, red and green under a colourless glaze, with six double pendants in red and green, and six in blue; leaf pattern below mouth; wave pattern above foot. Low foot ring; glazed base.
H: 18cm D: 18.2cm Ft.D: 7.5cm
Iran, late 17th–early 18th century
1978.1712

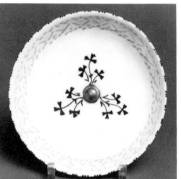

354 Bowl

Small bowl of soft-paste porcelain, with rounded body, slightly flaring sides, and a small dome in the centre. Decorated with pierced lines round the sides, and with blue and black under a colourless glaze: the dome in blue, surrounded by groups of black trefoils, and black dots on the rim. Low foot ring; glazed base.
H: 5.2cm D: 15.3cm Ft.D: 6.3cm
Iran, 'Gombroon' ware, 18th century
1978.1765

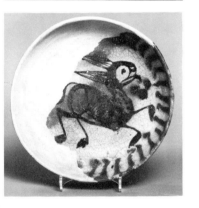

355 Dish

Dish of buff earthenware, with rounded sides. Decorated inside in purple and green on white slip under a crackled glaze, with a hare within a striped border; outside plain, unglazed. Pad foot.
H: 5cm D: 22.2cm Ft.D: 16.2cm
Egypt, 10th–11th century
1978.2161

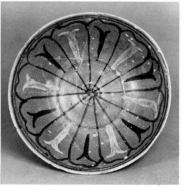

356 Bowl

Bowl of reddish earthenware, with rounded sides. Decorated in white slip and purple under a brownish glaze: inside, divided into twelve compartments with a stem in each; outside, eight compartments with a leaf. Low foot ring.
H: 7.3cm D: 22cm Ft.D: 7.1cm
Egypt, 14th century
1978.2160

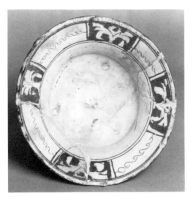

357 Bowl

Bowl of brown earthenware, with rounded lower body and outward-curving upper body. Decorated in white slip under a transparent greenish glaze: inside, below the rim, four palm trees reserved in white with 'S' ornament between; outside, diagonal bands of white naskhi letters on a brown ground. Flaring foot ring. (Monochrome plate p. 117)
H: 9.5cm D: 18cm Ft.D: 6.9cm
Egypt, late 14th–early 15th century
1978.2149

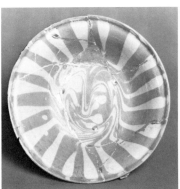

358 Bowl

Bowl of red earthenware, with rounded lower body, outward-curving upper body and upturned rim. Decorated in white under a colourless glaze: inside, the centre marbled, the sides striped; outside striped. Low foot ring.
H: 7.5cm D: 17.8cm Ft.D: 7.5cm
Egypt, 15th century
1978.2135

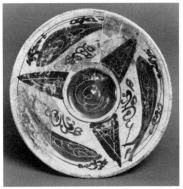

359 Bowl

Bowl of frit ware, with straight flaring sides. Decorated inside with lustre over transparent greenish glaze, with three fishes and three triangles round a central disc. Outside plain, glazed. Low flaring foot ring
H: 7.1cm D: 19.7cm Ft.D: 8.3cm
Syria, 'Tell Minis' ware, 12th century
1978.2289

360 Bowl

Shallow bowl of frit ware, with flaring sides and upturned rim. Decorated inside, with four incised arabesques picked out in runny blue under a colourless glaze; outside plain, glazed. Low flaring foot ring.
H: 6cm D: 18.9cm Ft.D: 9.3cm
Syria, 12th century
1978.2342

361 Dish

Small dish of frit ware, with rounded body and broad flat rim. Decorated in black under a turquoise glaze: inside, with papyrus plants and leaves; outside, with two bands of 'S' ornament. Flaring foot ring.
H: 4.5cm D: 21.7cm Ft.D: 7.5cm
Syria, 12th century
1978.2353

362 Bowl

Hemispherical bowl of thick frit ware, with flat rim. Decorated inside in blue and black under a colourless glaze, with a hunting dog against a background of foliage; dots on the rim; a single black line round the outside. Low foot ring.
H: 6.8cm D: 27.4cm Ft.D: 9.3cm
Syria, 'Raqqa' ware, late 12th–early 13th century
1978.2183

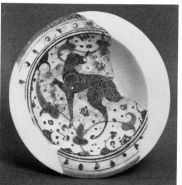

363 Bowl

Small hemispherical bowl of frit ware, with flat rim. Decorated inside with alternate blue and brown radiating stripes under a colourless glaze; a single dark line round the outside. Flaring foot ring.
H: 6.1cm D: 21.5cm Ft.D: 7.4cm
Syria, 'Raqqa' ware, late 12th–early 13th century
1978.2187

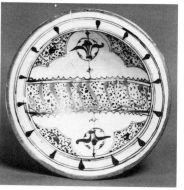

364 Bowl

Hemispherical bowl of thick frit ware, with flat rim. Decorated in brown and blue under a transparent greenish glaze: inside, a pseudo-naskhi inscription across the centre, with two wedge-shaped panels and a palmette above and below; dotted rim; a single brown line round the outside. Slightly flaring foot ring.
H: 7cm D: 26.8cm Ft.D: 9.2cm
Syria, 'Raqqa' ware, late 12th–early 13th century
1978.2188

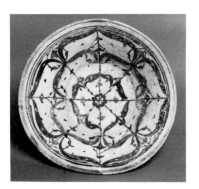

365 Bowl

Truncated conical bowl of frit ware. Decorated in brown and blue under a transparent greenish glaze: inside, three bands of confronted comma-like ornament; a single brown band round the outside. Tall foot ring, flaring slightly at the top. (Monochrome plate p. 127)
H: 11cm D: 22.2cm Ft.D: 7.6cm
Syria, 'Raqqa' ware, early 13th century
1978.2196

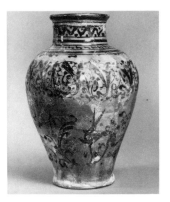

366 Jar

Squat jar of heavy frit ware, with bulbous sides. Decorated in black, blue and red under a thick transparent greenish glaze, with seven palmettes in whorls. Wide flaring foot ring.
H: 12cm D: 20.1cm Ft.D: 12.8cm
Syria, 'Raqqa' ware, early 13th century
1978.2185

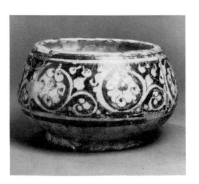

367 Jar

Jar of frit ware, with pear-shaped body, cylindrical neck and everted lip. Decorated in black under a turquoise glaze, with a naskhi inscription, probably of good wishes, round the shoulder, above a band of three running hares; bands of zig-zag on neck and 'S' ornament on upper shoulder. Low foot ring.
H: 25.4cm D: 17.8cm Ft.D: 9.5cm
Syria, 'Raqqa' ware, late 12th–early 13th century
1978.2499

368 Bowl

Hemispherical bowl of frit ware, with flat rim. Decorated in black under a transparent greenish glaze: inside, a central rosette within a border of nine semi-circular lappets; dots on rim; a single wavy line round the outside. Flaring foot ring.
H: 7.7cm D: 25.3cm Ft.D: 8.4cm
Syria, 'Raqqa' ware, late 12th–early 13th century
1978.2193

No. 365

No. 378

369　Bowl
Hemispherical bowl of frit ware, with flat rim. Decorated inside in black under a turquoise glaze, with four lobes around a crossed chain; curves and dots on rim; a single wavy line round the outside. Low, flaring foot ring.
H: 7cm D: 24.7cm Ft.D: 8.8cm
Syria, 'Raqqa' ware, late 12th–early 13th century
1978.2179

370　Bowl
Truncated conical bowl of frit ware. Decorated in chocolate-coloured lustre over a transparent greenish glaze: inside, in kufic, *al-surr*, 'joy', within bands of pseudo-naskhi script and large dots; outside, crude whorls. Tall foot ring, flaring slightly at the top.
H: 10.6cm D: 22cm Ft.D: 7.5cm
Syria, 'Raqqa' ware, early 13th century
1978.2175

371　Stem bowl
Stem bowl of frit ware, with almost vertical sides. Decorated in blackish-green, red and blue under a colourless glaze: inside, two half-palmettes in a medallion, and pseudo-kufic round the rim; outside, a band of geometric arabesque. Tall splayed foot ring.
H: 9.2cm D: 12.6cm Ft.D: 6cm
Syria, 13th century
1978.2214

372　Stem bowl
Stem bowl of frit ware, with rounded body. Decorated in blue, black and turquoise under a colourless glaze: inside, a complex of six-sided figures, a panelled band below the rim; outside, two black lines and various blue dots. The stem flared, with step half way up.
H: 10.7cm D: 21.3cm Ft.D: 7.2cm
Syria, 14th century
1978.1615

373 Dish
Dish of heavy buff earthenware, with rounded sides, flaring rim and upturned lip. Decorated inside in yellow-brown and green under a yellowish glaze, with an incised interlaced seven-pointed star, and a petal border on the rim; outside glazed green. Low foot ring.
H: 7cm D: 29.2cm Ft.D: 8.6cm
Syria, 14th century
1978.2218

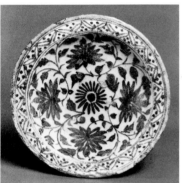

374 Dish
Small dish of heavy frit ware, with shallow hemispherical body and flat rim. Decorated in blue under a colourless glaze: inside, a central rosette surrounded by four peonies, and a border of double zig-zag lines and dots; outside, curved lines within double-line borders. Straight foot ring.
H: 6.3cm D: 24.2cm Ft.D: 7.8cm
Syria, late 14th–early 15th century
1978.2192

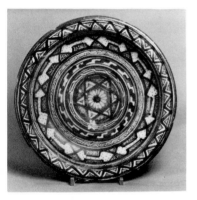

375 Dish
Dish of heavy frit ware, with rounded sides and flat rim. Decorated in black and blue under a thick transparent greenish glaze: inside, a central rosette in an interlaced six-pointed star, surrounded by a variety of narrow borders; outside, a band with vertical blue lines in threes. Low foot ring.
H: 8.4cm D: 33.8cm Ft.D: 10.7cm
Syria, late 14th–early 15th century
1978.1610

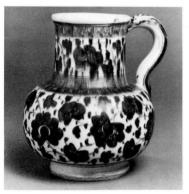

376 Tankard
Tankard of frit ware, with bulbous body, cylindrical neck and 'S'-shaped handle. Decorated in blue under a transparent glaze, with peony scrolls and borders of key-fret and cable-plait. Low flaring foot ring; glazed base.
H: 15.3cm D: 13cm Ft.D: 7.8cm
Syria, or possibly Turkey, late 15th century
1978.1736

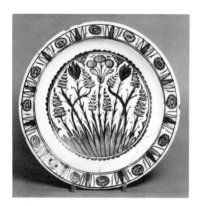

377 Dish

Dish of frit ware, with rounded sides and flaring rim. Decorated in black, green, blue and purple under a colourless glaze: in the centre, tulips and hyacinths with iris leaves, a flower and leaf pattern on the rim; outside, a meander with four flowers. Low foot ring; partially glazed base.
H: 7.3cm D: 32cm Ft.D: 10cm
Syria, mid 16th century
1978.1478

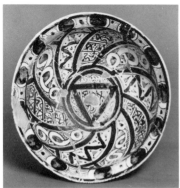

378 Bowl

Deep bowl of red earthenware, with rounded body and steeply sloping rim. Decorated on white slip under a colourless glaze: inside, in blue, a central triangle in a circle, surrounded by spiralling panels of alternating designs; blue discs on rim; outside, in green and brown, a wavy line on rim and a band of diagonal lines below. Deep splayed foot ring. (Monochrome plate p. 127)
H: 12.5cm D: 26.6cm Ft.D: 9.2cm
Turkey, 'Miletus' ware, early–mid 15th century
1978.1680

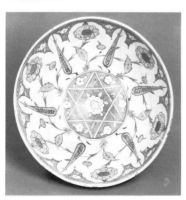

379 Bowl

Deep bowl of white paste, with rounded sides. Decorated in blue and turquoise under a colourless glaze: inside, a central six-pointed interlaced star in a roundel, surrounded by fourteen niches containing alternately, cypresses and prunus blossoms; outside, a meander with six peony flowers. Low foot ring; glazed base.
H: 13.7cm D: 28.5cm Ft.D: 13.2cm
Turkey, Iznik, c. 1520
1978.1776

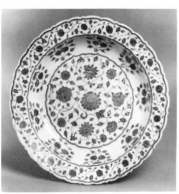

380 Dish

Dish of white paste, with rounded sides and flaring petalled rim. Decorated in slate blue under a colourless glaze: inside, a central lotus scroll design, eight floral clusters on the cavetto, a meander on the rim; outside, eight floral clusters. Stepped foot ring; glazed base.
H: 8cm D: 36.5cm Ft.D: 19cm
Turkey, Iznik, c. 1525
1978.1454

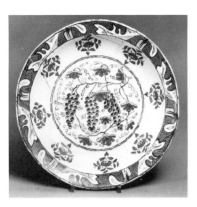

381 Dish

Dish of white paste, with rounded sides and flaring six-petalled rim. Decorated in blue and turquoise under a colourless glaze: inside, a central design of bunches of grapes, eight floral sprays on the cavetto, and a rock and wave design on the rim; outside, eight floral sprays. Low foot ring; glazed base.
H: 7cm D: 36.2cm Ft.D: 19.3cm
Turkey, Iznik, 1530–1540
1978.1468

382 Dish

Dish of white paste, with rounded sides and flaring petalled rim. Decorated in black, blue, purple, grey-green and turquoise under a colourless glaze. Inside, four peonies and four flower sprays around a central rosette, with rock and wave pattern on rim; outside, alternating flowers and leaves. Low foot ring; glazed base.
H: 6.7cm D: 29.5cm Ft.D: 15.2cm
Turkey, Iznik, 1540–1550
1978.1447

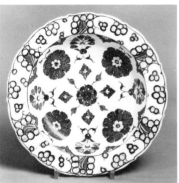

383 Tile

Tile of white paste. Decorated in black, blue, turquoise and lilac under a colourless glaze, with a formalised design of artemesia, ferns and peonies with prunus sprays.
H: 30.2cm W: 30.2 cm
Turkey, Iznik, 1540–1550
1978.1527

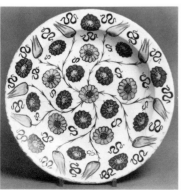

384 Dish

Dish of white paste, with rounded sides and flaring rim. Decorated in blue and turquoise under a colourless glaze, with tulips and chrysanthemums inside; outside, alternating pomegranates and tulips. Low foot ring; glazed base.
H: 6.2cm D: 33.3cm Ft.D: 17.8cm
Turkey, Iznik, 1540–1550
1978.1469

385 Pair of tiles

Pair of tiles of white paste. Each decorated in black, blue, turquoise and red under a colourless glaze, with a design of two interlacing stems, one with peony-like flowers, the other with serrated leaves, and stylised arabesque borders.
Each tile H: 35cm L: 36cm
Turkey, Iznik, 1550–1560
1978.1528 & 1978.1529

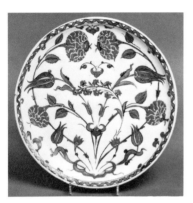

386 Dish

Dish of white paste, with shallow rounded sides and everted lip. Decorated in black, blue, green and red under a colourless glaze: inside, a spray of tulips and chrysanthemums within a border of zig-zag; outside, alternating rosettes and leaves. Low foot ring; glazed base.
H: 3.8cm D: 28cm Ft.D: 15.6cm
Turkey, Iznik, 1560–1570
1978.1423

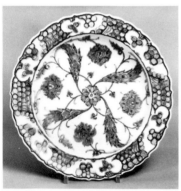

387 Dish on stand

Dish of white paste, with rounded sides, flaring petalled rim, and a high flaring foot ring forming a stand. Decorated in blue under a colourless glaze: inside, four whirling ferns with peonies between; rock and wave pattern on rim; outside, two sets of alternating rosettes and ribbons. Glazed base.
H: 8.8cm D: 32.2cm Ft.D: 20.5cm
Turkey, Iznik, c. 1580
1978.1467

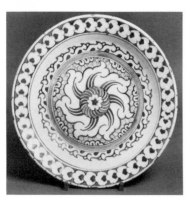

388 Dish

Dish of white paste, with rounded sides and flaring rim. Decorated inside in blue, black, red and turquoise under a colourless glaze, with a whirling rosette in a medallion; prunus blossom border on rim; outside plain, glazed. Low foot ring; glazed base.
H: 5.7cm D: 31.3cm Ft.D: 17.8cm
Turkey, Iznik, 1590–1600
1978.1452

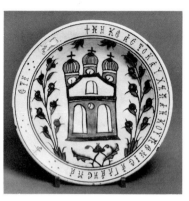

389　Dish

Dish of white paste, with rounded sides and flaring rim. Decorated in black, brown, blue and green under a colourless glaze: inside, a three-domed church between plants, with a Greek inscription on the rim, translated 'Nicaea, the boast and glory of the inhabited world—anno . . .', the date obliterated. Outside, five small circles. Low foot ring; glazed base.

H: 5.5cm D: 25.5cm Ft.D: 12.8cm
Turkey, Iznik, 1660–1670
1978.1451

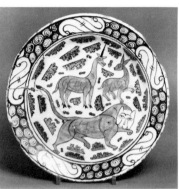

390　Dish

Dish of white paste, with rounded sides and flaring rim. Decorated in black, blue, green and fawn under a colourless glaze: inside, a lion, a unicorn and a deer amid tufts of vegetation; cloud and wave pattern on rim; outside, six crude rosettes. Low foot ring; glazed base.

H: 5.5cm D: 30.7cm Ft.D: 15.1cm
Turkey, Iznik, 1650–1670
1978.1464

Islamic miniatures

Gerald Reitlinger's collection of Islamic miniatures was neither large nor outstanding, though it did contain a few attractive paintings. Sadly, one of the most interesting items, a fifteenth-century drawing of cranes in the Chinese style, appears to have been lost in the fire. This had been one of Mr Reitlinger's first purchases, and had been acquired during his undergraduate days from the Eastgate Gallery, Oxford. His collection also contained a group of problem paintings, those from al-Qazvīnī's *Ajā 'ib al-Makhlūqāt* (Nos 395–397), whose dating has been the subject of continuing discussion. Similar illustrations in another such manuscript, now in the Freer Gallery of Art, Washington, are assigned to late fourteenth-century Mesopotamia, and one of Mr Reitlinger's examples was recently attributed to fifteenth-century Syria. However, the drawing of faces and hair in these illustrations suggests that they are more probably to be assigned to Safavid Iran. The other miniatures of note in the collection are also Safavid, and include signed works by Sādiqī (No. 394), and by Mu ʿīn Musavvir (No. 399), though signatures on Persian miniature paintings are usually contested.

J. W. Allan

391 The Archangel Israfil supporting the moon.
From a manuscript of the Persian version of Qazvīnī's
'Ajā 'ib al-Makhlūqāt, 'The Marvels of Creation'.
22.5cm × 12.5cm
Qazvin, *c*. 1560
1978.2573

392 A shepherd offering a kid to a prince on horseback.
21cm × 12cm
Probably Mashhad, *c*. 1570
1978.2562

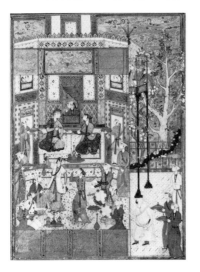

393 Bahrām Gūr in the Green Pavilion.
From a manuscript of Nizāmī's *Khamseh*, 'Quintet'.
24cm × 17cm
Shiraz, 1570–1580
1978.2565

394 Darvish seated on a rug.
Line drawing touched in red. Signed, *Sādiqī*.
15cm × 11cm
Iran, 1590–1600
1978.2570

395 The constellations Arcturus and Sirius, depicted as a
raven and a winged centaur respectively.
From a manuscript of Qazvīnī's *'Ajā 'ib al-Makhlūqāt*,
'The Marvels of Creation'.
27.5cm × 15cm
Iran, late 16th–17th century
1978.2576

396 The zodiacal signs Aries and Aquarius.
From a manuscript of Qazvīnī's *'Ajā 'ib al-Makhlūqāt*,
'The Marvels of Creation'.
30cm × 17.5cm
Iran, late 16th–17th century
1978.2575

397 Two giants.
From a manuscript of Qazvīnī's *Ajā 'ib al-Makhlūqāt*,
'The Marvels of Creation'.
28.5cm × 15.5cm
Iran, late 16th–17th century
1978.2577

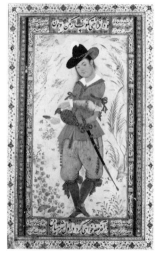

398 Court page in European dress.
Possibly by Riżā.
19.5cm × 10.5cm
Isfahan, 1625–1650
1978.2569

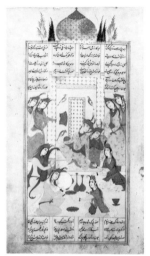

399 Bahrām Gūr in the Red Pavilion.
From a manuscript of Nizāmī's *Khamseh*, 'Quintet'.
Signed, *Mu 'īn Musavvir*.
26cm × 11cm
Isfahan, 1660–1680
1978.2572

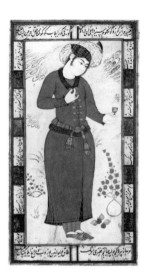

400 Court page holding a wine cup.
20cm × 9.5cm
Isfahan, early 18th century.
1978.2567

Indian miniatures

Miniature paintings were not one of Gerald Reitlinger's dominant interests as a collector. The number of Indian miniatures in his collection is small. Nevertheless, the selection exhibited shows his characteristic alertness to the factors which make one work of art more important or more desirable than another. In this field, his wide knowledge of art history served him particularly well. The spirited painting from the *Hamza Nāmeh* (No. 401), the famous project initiated by the Emperor Akbar, is a case in point. Under the direction of two Persian masters, scores of painters, including many Indians, were enlisted in this vast undertaking; it became the crucible in which the Mughal style was formed and produced what is indisputably the most important of all Indian illustrated manuscripts. Although almost certainly one of the earliest paintings in the great series, the example exhibited manifests the boldness of scale and the vigorous, and even boisterous, depiction of action scenes which mark such a revolutionary departure from contemporary Persian painting.

Similarly, the copy of a figure in a Dürer engraving by Abu 'l-Ḥasan, a work of astonishing virtuosity for a twelve year old boy, is, on account of its two inscriptions, of great individual importance to the art history of the period (No. 408). Thanks to them, more is known about Abu 'l-Ḥasan, the future 'Wonder of the Age' and a favourite of the Emperor Jahāngīr, than about any other important painter of the time. The latter's patronage of painters from his early manhood onwards has also been inferred from these inscriptions.

The paintings that illustrate the six folios from the now widely dispersed *Razm Nāmeh* manuscript of 1598 were, except for Manohar, of a different order of magnitude (Nos 402–407). Their names have now all been ascertained from the inscriptions below the paintings. Often the sons or brothers of better-known painters, all but one, Jamāl, are known by other work on this manuscript. Labels in Persian have enabled the scenes from the Hindu epic *Mahābhārata* (the *Razm Nāmeh* is a compilation from this work in Persian) to be identified.

Finally, one of Gerald Reitlinger's last acquisitions, the lively bazaar scene from Guler (No. 409), unfortunately damaged, is one of the very rare examples in Hill painting, and an early one at that, of this kind of realistic genre scene.

J. C. Harle

401 Amīr Hamza overthrows Amīr ʿImād Kāriba in battle.
From the *Hamza Nāmeh*. Painting on cloth. (Colour plate VII)
49cm × 32cm
c. 1562
1978.2596

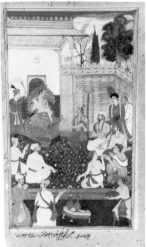

402 Bhīṣma giving advice to Yudhiṣṭhira in the matter of the four *varṇas*.
From a *Razm Nāmeh* manuscript. By Jamāl, son of Muvāfi
23cm × 13.5cm
1598
1978.2589

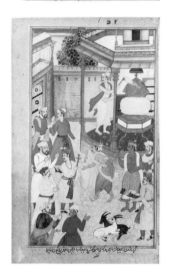

403 Kṛṣṇa reconciles Yudhiṣṭhira and Arjuna.
From a *Razm Nāmeh* manuscript. By Fattū.
22cm × 13cm
1598
1978.2590

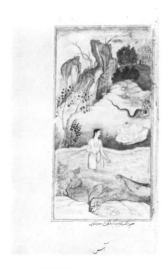

404 The sage Uttanka in the river while Takṣaka, the
Serpent King, steals the bracelets.
From a *Razm Nāmeh* manuscript. Grisaille faintly
coloured. By Ās.
20cm × 10.5cm
1598
1978.2591

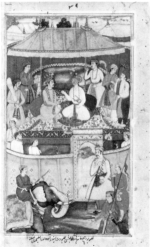

405 Kṛṣṇa advises a King, possibly Mandhātṛ, having
come to him in the guise of Indra.
From a *Razm Nāmeh* manuscript. By Ṣadiq, and faces by
Manohar.
24cm × 14cm
1598
1978.2592

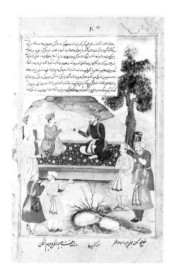

406 Bhīṣma instructing Yudhiṣṭhira in the recognition of
the *jīvātman* and the *dharmātman*.
From a *Razm Nāmeh* manuscript. By Aḥmad Kashmiri.
22cm × 15cm
1598
1978.2593

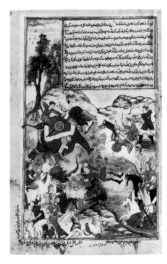

407 Scene of battle opposing Duryodhana, the Aṅga King and, possibly, his son Mahāvir, against the Pāṇḍava brothers, Nakula and Sahadeva and their allies.
From a *Razm Nāmeh* manuscript. By Mohan, son of Banwārī.
24cm × 15cm
1598
1978.2594

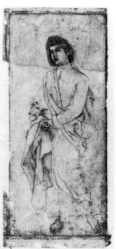

408 Figure of St John the Evangelist copied from the engraving of Christ on the Cross in the 1511 Passion series of Albrecht Dürer (F. W. H. Hollstein, *German Engravings, Etchings and Woodcuts*, vol. VII, no. 13 (1954–).
Faintly tinted and enhanced with gold. By Abu 'l-Ḥasan.
10cm × 5cm
1600
1978.2597

The work of the painter at the age of twelve. Two inscriptions provide this and other valuable information about this famous painter. (Monochrome plate p. 145)

409 Bazaar scene.
20.5cm × 26.5cm
Guler, Hill States, *c.* 1720
1978.2595

No. 408

410 Lovers on a terrace.
19cm × 11cm
Bikaner, Rājasthān, *c.* 1740
1978.2584

411 Kṛṣṇa seated on a palace balcony with women.
25cm × 17cm
Probably Kotah, Rājasthān, 1770–1780
1978.2568

European ceramics

Gerald Reitlinger's collection of European ceramics always took second place to his Oriental and Islamic collections, even before the unhappy fire which destroyed half of it. Nor, perhaps, is it equal in quality to those which it joins in the museum. Certainly that was the first impression when the surviving 213 pieces, battered and full of ash and rubble, the jugs and albarelli still containing the firemen's water, were unpacked in June 1978. His own previous, amateurish, attempts at restoration with the use of 'Sellotape' here, or gold paint there, did little to improve the appearance of what looked, and smelt, like wreckage.

Having been washed and ordered, card-indexed and completely rearranged over the subsequent two years, the collection now manifests its usefulness. Where the collections of such benefactors as C. D. E. Fortnum, Sir Bernard Eckstein and H. R. Marshall are renowned for their discrimination and high quality, Mr Reitlinger's complements them at a simpler level, which only reveals its interest on examination. His pieces are more popular, the English creamware plate with Dutch decoration of 1787 (No. 435), for instance, or even everyday, as in the Fulham jug, hallmarked 1774 (No. 417), which is not to deny that there are fine and rare ones too, such as the Bristol delftware plaque (No. 432), or the large maiolica dish attributed to La Terza, Apulia (No. 420).

It was in compiling the department's card index and going over Mr Reitlinger's records, that a fuller understanding of its nature became apparent. His enthusiastic pursuit of objects, his evident pleasure in an exchange, usually to his advantage, or a cheap purchase, were allied to the serious purpose of bringing together comparative pieces which reflected the influence of the Orient on European earthenwares, in Germany (No. 425), the Netherlands (No. 422) and England (No. 431). In accumulating a large variety of both stone and earthenwares from the sixteenth to the nineteenth century, his interest in type and pattern is demonstrated. An analysis of the categories reflects this:

| Stonewares: | German | 24 |
| | Other European | 10 |

It is sad that his own taste for the German stonewares, one which he shared with his brother, Henry Scipio Reitlinger, is no longer represented in the balance of the collection, because it was these that sustained the most fire damage. Fortunately for

the museum it is already rich in this respect, having the Southworth Collection.

Earthenwares:	Spanish	11
	Italian	12
	Dutch	29
	German	20
	English	39
	French	16
Porcelain:		30
Miscellaneous (including creamware):		33

There is relatively little porcelain and here the Reitlinger Collection reverses the proportions of that of Cyril Andrade, another benefactor, although the personality of both collectors still survives, individual, even eccentric, but wide ranging and varied. In turn, the necessarily limited selection shown here is intended to reflect Mr Reitlinger's tastes, and porcelain has been omitted.

Another aspect of the collector which was revealed by Mr Reitlinger's own careful records, was his curiosity and pertinacity in pursuit of a correct identification. While he had his own firm beliefs and, like many collectors, not all his geese proved to be swans, he was always showing his ceramics to other collectors and curators and noting down their comments, a tradition which has continued. The advice given by Dr Jaeger on the Frankfurt faience, the first such examples together with those of Hanau to enter the museum, and that of Anthony Ray, particularly on the delftware and tiles, but in numerous other cases as well, must be gratefully acknowledged. There will probably always be differences of opinion on attributions. These were characteristically illustrated, to quote Mr Reitlinger's words, by the

> white-glazed group, Europe [now in need of repair, and so not in the exhibition] from the Four Continents . . . Condition: The fingers of the outstretched hand are in plaster, also parts of the neck and helmet and the tips of the horse's ears. Period *c.* 1750–60. By exchange George Savage. 23.3.64 £22. *Factory uncertain.*

The six people who saw it offered five different attributions: German, Buen Retiro, Vincennes (two), Crépy-en-Valois and Mennecy. At present it rests under the penultimate one. The large French faience jar (No. 428), is in need of similar consideration.

The present selection is a fair sample of Gerald Reitlinger's European ceramics. His English delftware has enriched the Warren Collection. A selection of the Dutch and German seventeenth-century pieces has already been shown with the contemporary still life paintings in the Ward Gallery. There are plans for a temporary exhibition of the museum's small but growing collection of nineteenth-century ceramics. In these ways the Reitlinger Gift will serve as a stimulus, and, thanks to the provision of new shelving, it is still readily available to scholars.

I. Lowe

412 Tankard with silver mounts

Raeren stoneware

Round-bellied tankard in brown glazed stoneware, with cylindrical neck. Long splat at base of handle. Three medallions on neck depict a man in armour, a bearded man and a lady in Holbein-style headdress. Phoenix in foliage either side of lady. *Kerbschnitt* ornament on body. Colour paling to grooved foot. A silver collar, with stamped repeat frieze of three Bacchants in procession: probably English, *c.* 1620.

H: 21cm D: 15.2cm Ft.D: 9.6cm
c. 1580
1978.130

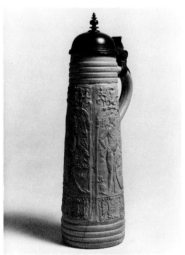

413 Schnelle with pewter mounts

Siegburg stoneware

Schnelle in white stoneware. Relief decoration of three identical panels, depicting King Arthur in a suit of half armour and feathered hat, holding a baroque shield with three crowns of Cologne, and helmet by right foot. Scroll above head inscribed, *CUNIG ARTUS 1588*. Crest with supporters above and coat of arms below. Style of Hans Heilgers. Pewter mounts, stamped inside with monogram, *H.B.*, under a rosette: German, *c.* 1600.

H: 28cm D: 8.1cm Ft.D: 8cm
1588
1978.133

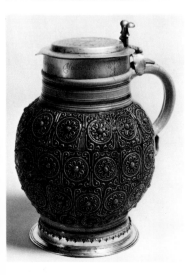

414 Tankard with silver mounts

Westerwald stoneware

Round-bellied tankard in grey stoneware, with ridged neck and foot in blue. Body decorated with blue glaze, except near handle, over fifty-one applied medallions. Silver mounts with finger rest on box hinge, engraved round neck, *POCULUM CHARITATIS IN ETERNAM MEMORIAM W W*, with flower between 'W's; the lid engraved with a coat of arms surrounded by foliage and, *EX DONO THOMAE CLERKE ARMIGERI*: English, dated on base, *1652*, with *IAM* and *LI*.

H: 23cm D: 15.3cm Ft.D: 12.6cm
First half 17th century
1978.136

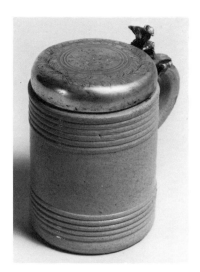

415　Tankard with silver mounts
Westerwald stoneware

Cylindrical tankard in glazed cream stoneware, with five ridges at top and base. Handle ridged. Unglazed base. Silver mounts, the lid engraved with a laurel wreath and attached to handle with parakeet above grip: probably Dutch, engraved *GL.S.ST/A.E.D./1695.*
H: 10cm D: 7cm
c. 1690
1978.142

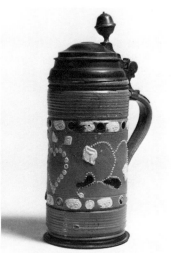

416　Tankard with pewter mounts
Altenburg saltglazed stoneware

Cylindrical tankard in light brown saltglazed stoneware, with ridges top and bottom. Decorated between ridges in white and blue slip, with pendant heart and stylised flowers in relief. Mounted in pewter, with bullet grip on the lid and strap work on handle: German, *c.* 1720.
H: 25cm D: 9.3cm Ft.D: 10.2cm
c. 1720
1978.146

417　Jug with silver mounts
Fulham stoneware

Jug in yellow-brown glazed stoneware. Reeded handle decorated below with rivet and oak leaf pattern in relief. Colour paling to foot. Unglazed base, incised, *EG*, before firing. Mounted in silver, with lambrequin edge to collar and urn-shaped knop on lid. Maker's mark, *W.S.*: hallmarked in London, 1774.
H: 23cm D: 14.6cm Ft.D: 10cm
1750–1770
1978.150

418 Dish
Palissy ware, Avon period
Oval dish of Palissy ware, with lambricated border striped white on deep blue glaze. Central decoration in relief, with a bearded man in a brown smock, crowned with vine leaves and grapes, walking between a tub of grapes and a jar. He carries a cluster of fruit on his right arm and a basket of grapes in his left hand. Sickle in belt. Outside, marbled with thumb grip and foot ring.
H: 5cm D: 27cm Ft.D: 12.5cm
Early 17th century
1978.157

419 Plate
Castelli, maiolica
Plate in tin-glazed earthenware, with flattened rim. Over-all polychrome decoration, with a landscape of figures on the podium of a ruined Roman temple among trees, looking towards buildings in the middle distance below mountains. Outside plain. Studio of Laborio Grue.
H: 1cm D: 17.5cm Ft.D: 13.3cm
c. 1750
1978.173

420 Dish
La Terza, Apulia, maiolica
Fluted dish in blue and white tin-glazed earthenware, with elaborate frilled rim, deep cavetto moulded in sixteen sunken panels, and raised central boss. Elaborate inner and outer borders of Renaissance-type meander pattern with pendant fruit swags and tassels between naturalistic birds. Landscape scene in centre with buildings and figures. Outside plain.
H: 3cm D: 42cm Ft.D: 33cm
c. 1720
1978.178

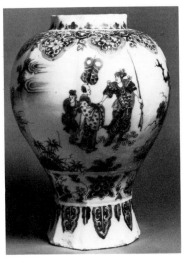

421 Vase
Dutch delftware
Octagonal baluster-shaped vase in blue and white tin-glazed earthenware, with short neck. Chinese-inspired design, with three main scenes in Transitional Ming style, influenced by Jean Berain; three sages seated before a lady with attendant; two men by a horse; a warrior carrying a lance, with two men. Lappets on shoulders and late Ming-style flags towards the foot, surmounted by four landscapes in cartouches between stylised flowers. The base partly glazed, with a mark, S⅄E/22, for Samuel van Eenhorn.
H: 32cm D: 23.2cm Ft.D: 13.5cm
c. 1680
1978.188

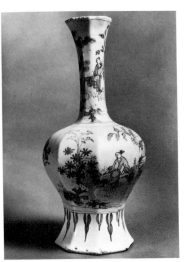

422 Vase
Dutch delftware
Vase of octagonal section with long trumpet neck, in manganese and white, tin-glazed earthenware. Ming-style decoration, with Chinese figure and prunus, pines and plantains on neck. Two scenes on body, with one figure in one and two in the other, among plantains, pines, bamboo, grass, waterfalls and mountains in clouds. Flag pattern on splayed foot. The base, with a mark, *VI*, possibly for Lambertus, or Samuel, van Eenhorn.
H: 29cm D: 13cm Ft.D: 10cm
1670–1680
1978.190

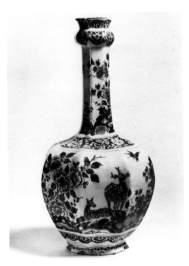

423 Vase
Dutch delftware
Long-necked vase of octagonal section, in blue and white tin-glazed earthenware, with slightly concave panels and a bulb rim to the neck. Rim and foot, decorated with *ruyi* lappets. On the neck, peony, prunus, flying bird and rock design. White peonies reserved on blue on the shoulders. Body decorated with a standing buck and sitting doe, among peony, speckled iris, narcissus and flying birds. The base, with a mark, NO II/4/⅄K/9, for Adriaen Koeks, and foot ring.
H: 32cm D: 15.7cm Ft.D: 8.7cm
1700–1725
1978.199

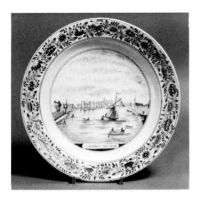

424 Dish

Dutch delftware

Dish in blue and white tin-glazed earthenware, with sloping rim and deep cavetto. Decorated inside with Chinese-style flowers and foliage on rim; blank cavetto edged with two lines; in the centre, view of a Dutch fishing village with boats, and an inscription, *ZAANDAM VAN VOREN*. Foot ring with vertical sides. The base, with a mark, 及 , possibly for Lambertus Saunderus of De Klauw.

H: 5.1cm D: 34.5cm Ft.D: 18.6cm
c. 1765
1978.202

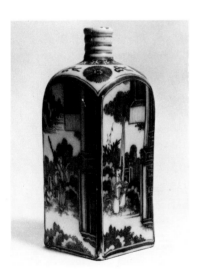

425 Bottle

Frankfurt faience

Schnapps bottle of square section, in blue and white tin-glazed earthenware, with rounded shoulders and circular ridged neck. Ming-style decoration in deep blue stipple of four different scenes, each showing a figure in landscape. Star pattern on the shoulders. Base partly glazed.

H: 27cm W: 11.7cm
c. 1680
1978.223

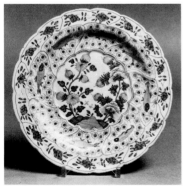

426 Plate

Bayreuth faience

Plate in blue and white tin-glazed earthenware, with petalled rim. Moulded panels on cavetto, with petalled edge towards centre. Decorated with peonies on rim, and marine animals among daisy-style flowers in cavetto panels. Chinese-style chrysanthemums, peonies and pomegranates in centre. Outside, with three peony sprays and simulated Kangxi shop mark in double circle. Shallow foot ring.

H: 1.8cm D: 23.5cm Ft.D: 11cm
c. 1740
1978.230

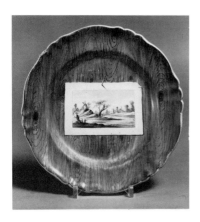

427 Plate
Niderviller faience
Plate in tin-glazed earthenware, with six-lobed gilt rim. Decorated in *decor bois* style, simulating grained wood; in the centre, a trompe l'oeil of a nailed print with purple camaieu landscape in the style of Deutsch. Outside plain, with purple mark, *CN*, for Custine, Niderviller, and foot ring with sloping sides.
H: 2.7cm D: 23cm Ft.D: 13.5cm
c. 1775
1978.236

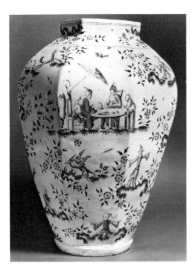

428 Jar
South French faience
Large jar of octagonal section, in tin-glazed earthenware. Imari shape and heavily tapered. Polychrome decoration in the style of Pillement, with two Chinese scenes and numerous Berainesque dancers, heraldic monsters, and animals among flowers and leafy branches. Slightly buttress foot. Roughly glazed base with a mark, *LSC*, in cursive script.
H: 52.5cm D: 36cm Ft.D: 17cm
c. 1775
1978.240

429 Plate
Lambeth delftware
Plate in blue and white tin-glazed earthenware with sloping rim. Over-all landscape, with woman leaning against an indeterminate mound pointing at classical ruins. Near her stands a man with hoe. Numerous sponged trees. Outside plain, with a mark, *19*, in blue on rim. Shallow foot ring.
H: 2.8cm D: 23.5cm Ft.D: 14cm
c. 1760
1978.248

430 Vase
Lambeth delftware
Long-necked vase in blue and white tin-glazed earthenware. Chinoiserie decoration in Pillement style, with tall tree, two figures, one seated and one standing, and several buildings in a watery landscape.
H: 21.5cm D: 12.5cm Ft.D: 7.2cm
1770–1780
1978.251

431 Dish
Bristol delftware
Dish in blue and white tin-glazed earthenware. Flat rim with twenty-four lobes, decorated in *bianco-sopra-bianco*, with frieze of fruit and leaves. Chinoiserie-style landscape in centre, with sampan, rocks, men and trees, encircled by a narrow border simulating *famille rose*. Outside, with four olive sprays on rim. Foot rim with sloping sides.
H: 3.8cm D: 34cm Ft.D: 18cm
c. 1760
1978.258

432 Plaque
Bristol delftware
Plaque in tin-glazed earthenware, with Italianate landscape in blue of a hill-top village centred on a church, with mountains in the distance. Trees sponged in olive green.
H: 24.5cm L: 37cm
c. 1750
1978.269

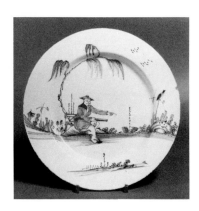

433 Dish
Bristol delftware
Dish in blue and white tin-glazed earthenware, with sloping rim and deep cavetto. Over-all decoration, with a Chinaman seated under a willow tree, holding a baton and pointing at an aloe, a perching bird above rocks behind. Outside plain. Foot ring with sloping sides.
H: 4cm D: 33.5cm Ft.D: 17cm
c. 1760
1978.280

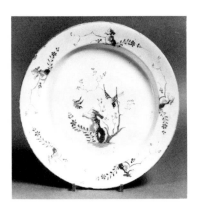

434 Dish
London delftware
Dish in polychrome tin-glazed earthenware, with sloping rim and deep cavetto. Chinoiserie decoration with five repeat designs of rocks and floral sprays on rim, and larger but similar design in centre, with flying bird and perching bird. Outside plain, with shallow foot ring.
H: 5.4cm D: 35cm Ft.D: 20.5cm
1760–1770
1978.288

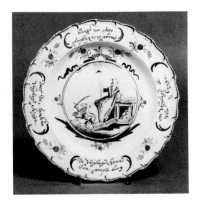

435 Plate
Leeds creamware
Plate in creamware, with feathered edge to rim. Decorated in Holland, with medallion in centre of Liberty, in grisaille and flesh tones, with a lion bearing sword and arrows. Ringed in green, with sprays of orange branches and scrolls above and below. On the rim, four numbered panels, containing a poem in Dutch relating to the return of the royal family in 1787, *DE VRYHEYD SPAND EEN GROOTE BOOG/OM VRYHEYD TE VER KRYGE/MAAR DIN VRYHEYD LEEF OM HOOG/DOTE DE AARSCHE VRYHEYD SWYGE*, 'Freedom draws a great bow/in order to obtain freedom/but your freedom lives on high/so earthly freedom must keep silent'. Outside plain, with shallow foot ring.
H: 2.4cm D: 25cm Ft.D: 14.5cm
c. 1787
1978.295

European paintings and drawings

Gerald Reitlinger was himself an artist of professional standard. After Oxford, he went on to the Slade and the Westminster School of Art. To begin with, he exhibited regularly but he seems to have given up painting with the Second World War. When one went to his house, there was little evidence of his own work, although there were many canvases stacked in a room upstairs. The paintings and drawings which hung on the walls were mostly collectors' pieces. These were included in his gift to the Ashmolean and, fortunately, they were in those parts of the house which were least damaged by the fire. The only ones to suffer were a small landscape by Joshua Shaw, a harbour scene by Spencer Gore and a beach scene by Adrian Daintry. The remainder are not numerous, but they are remarkably various, and among them are one or two things, notably the Calvert (No.439) and the Vispré (No.441), of very high quality indeed. The Calvert is not recorded in the literature on the artist and is a most apt and enticing acquisition for the Ashmolean, which already has such a good collection of works by Samuel Palmer and his circle. Among the items which are not included in the exhibition, are a delectable small Etty and some fine leaves from a fifteenth-century Book of Hours of the School of Tours. It is clear that in this field Mr Reitlinger bought just those things which he happened to like, and they show how wide-ranging and personal his sympathies were. He bought works by his friends, the Calvert from a shop and the Vispré from a sale room, because they appealed to him. He liked the sardonic humour of Rowlandson (Nos 437, 438) and he liked something odd, such as the curious *Allegory of Youth and Age* (No.436) which may, or may not, be Danish. His bequest has enriched the Department of Western Art in unexpected and most welcome ways.

K. J. Garlick

157

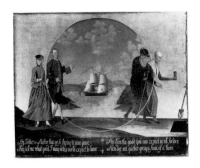

436 Anonymous, possibly Danish, 18th century
Allegory of Youth and Age
Oil on canvas: 62cm × 78cm
Inscribed, *My Father & Mother that go so stuping to*
 Your grave
 Pray tell me what good I may in this
 World expect to have
 My Son the good you can expect is all
 forlorn
 Men doe not gaether greaps from of a thorn.
A series of similar paintings is said to be in a church at
Lyngby, Jutland.

437 Thomas Rowlandson, (1756-1827)
Visit to an old Acquaintance
Pen, reddish-brown ink, and watercolours:
37.3cm × 28.4cm
Inscribed with the title, signed and dated, *Rowlandson*
1819.
Literature: Sacheverell Sitwell, *Narrative Pictures*
(1937), pl. 16.
There is a smaller version in the Mellon Center for British
Art, Yale University.

438 Thomas Rowlandson, (1756-1827)
The Corsican, his two Friends, and his Blood Hounds at the
Window of the Thuilleries looking over Paris
Pen, brown ink and watercolours: 23.5cm × 35.8cm
Napoleon stands with Marshal Ney on his right, Death
and the Devil beside and behind him. Inscribed with the
title and, *More Horrers Death Hell and Destruction.*
Provenance: Possibly W.T.B. Ashley; L. Delatigny (Lugt
1768a).
Etched and published by R. Ackermann, April 1815.

439 Edward Calvert, (1799-1883)
Psyche at the stream
Oil on card: 30cm × 50.5cm
Inscribed on the reverse, *Psyche Fluvium Desitet*, and,
exhibited R.A. 1836. In 1836 Calvert exhibited at the Royal
Academy only an *Eve* with the text 'And like a wood
nymph light . . .', from *Paradise Lost.* (Colour plate VIII)
Exhibited: London, Carfax Gallery, 1922.

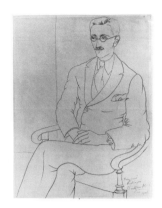

440 Christopher Wood, (1901–1930)
Portrait of Gerald Reitlinger
Blue chalk: 63cm × 48.5cm
Inscribed, signed and dated, *To my friend/
Reitlinger/Christopher Wood/Paris/1926.*
(Frontispiece)

441 François-Xavier Vispré, (1730–*c*.1790)
*A Gentleman, possibly John Farr, reading 'The Odes' of
Horace*
Pastel: 44.5cm × 60.5cm
Signed, *Vispré Pinx*, on the fore-edge of a book on the sofa.
Provenance: Lord Aldenham sale, Sotheby's, 24 February
1937, lot 27, as by Victor Vispré, brother of François-Xavier.
Exhibited: Whitechapel Art Gallery, Spring Exhibition,
1906, Upper Gallery, no. 106, as a portrait of John Farr.
George Gibbs, a brother of the 1st Lord Aldenham married
as his first wife, *c*. 1776, Esther Joanna, daughter of
Richard Farr of Bristol and heiress of her brothers, one of
whom may be the subject of this picture.